THE ESSENTIAL™

Hieronymus Bosch

BY W. JOHN CAMPBELL

THE WONDERLAND
PRESS

Harry N. Abrams, Inc., Publishers

THE WONDERLAND PRESS

The Essential™ is a trademark
of The Wonderland Press, New York
The Essential™ series has been created by The Wonderland Press

Series Producer: John Campbell
Series Editor: Harriet Whelchel
Project Manager: Adrienne Moucheraud
Series Design: The Wonderland Press

Library of Congress Catalog Card Number: 99–69223
ISBN 0-7407-0726-4 (Andrews McMeel)
ISBN 0-8109-5810-4 (Harry N. Abrams, Inc.)

Copyright © 2000 The Wonderland Press
Unless otherwise indicated, all works are courtesy Art Resource, NY

Published in 2000 by Harry N. Abrams, Incorporated, New York
All rights reserved. No part of the contents of this book may
be reproduced without the written permission of the publisher
Distributed by Andrews McMeel Publishing
Kansas City, Missouri 64111-7701

On the end pages: Detail from *Christ Carrying the Cross*
Museum voor Schone Kunsten, Ghent

Unless otherwise noted, all works are oil on panel

Printed in Hong Kong

Harry N. Abrams, Inc.
100 Fifth Avenue
New York, NY 10011
www.abramsbooks.com

PHOTOGRAPH CREDITS: Scala: 4, 8, 24, 25, 27, 30, 43, 47, 54, 59, 61, 62, 68, 80, 85, 92, 93, 94, 96, 100; Erich Lessing: 6, 22, 26, 29, 44-45, 58, 86, 87, 88, 89, 99; Cameraphoto, Venezia: 11, 14, 17, 84; Giraudon: 72-73, 105; KEA: 76, 79

Contents

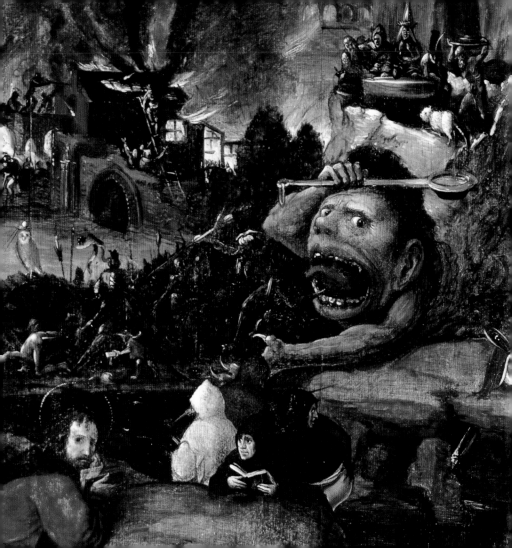

We're no longer in Kansas

Long before Internet "gif" photos popped up in online chat rooms, there was cave art. Somewhere in between, poster shops opened their doors. And even if you're not into gardening, chances are you purchased (or know someone who did) the bestselling poster of all time for your bedroom or (more likely) your college dorm room: Hieronymus Bosch's enchantingly weird *Garden of Earthly Delights*—the painting that led some to snicker that Bosch was a big druggie and others to champion him as one of the great artists of all time.

Brave New (Art) World

What gives with this zany painter whose 15th-century art would later thrill the 20th-century Surrealists? Tragically, we know almost nothing of his early life, and much of what we *do* know about him is subject to debate and opinion. Like the 17th-century Dutch painter **Johannes Vermeer** (1632–1675), he is a near-total enigma to us—which is, of course, annoying, since enquiring minds want to know about his family life, early influences, and reasons for becoming an artist. About 25 paintings and 40 drawings that remain today are believed to have been created by Bosch. But none of them is dated, and critics disagree about their authenticity and chronology. To make matters worse, many paint-

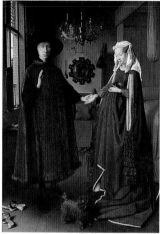

Jan van Eyck
*Giovanni Arnolfini
and His Bride*
1434. 33 x 24 ½"
(84.15 x 57.4 cm)

ings that were identified in documents of his time as being works by Bosch no longer exist today.

So where does that leave us?

Well, with a hodgepodge bundle of paintings that millions find irresistible—paintings that open up to us the hypnotic world and imagination of this orthodox, pious Roman Catholic. He lived in a time of growing religious tension (what else is new?), which led to the upheavals of the Reformation within the Catholic Church. As a devout Catholic, he took seriously his duty to combat the witches, demons, pagans, and ever-hated Muslims whose onslaught against Catholicism was an attack against the very fundaments of Bosch's beliefs. Born into a family of artisans, Bosch eventually rose to prosperity and earned the respect of his fellow *burghers* (i.e., solid citizens). From this revered vantage point, he never tired of lecturing people on the dangers of their un-Christianlike behavior.

Blazing new Trails

The tantalizing art created by this God-fearing Catholic emerged from a northern Gothic tradition of realistic descriptions of natural facts (blah, blah…).

And while his art owes a debt to the conservative, well-crafted traditions of the 15th-century Flemish realist painter **Jan van Eyck** (c. 1390–1441), known for such important works as *Giovanni Arnolfini and His Bride*, the perplexing results in Bosch's work are uniquely his and not mere copies of established conventions. The simple truth to grasp about Bosch's works is that they were inspired by his unswerving belief in God, in the inevitability of the Final Judgment, and in the existence of Hell. Not even the members of the clergy—worldly sinners, all—escaped his scorn and skepticism.

Sound Byte:
"This master of the monstrous, this discoverer of the Unconscious."
—CARL GUSTAV JUNG, Austrian psychoanalyst

A Turning Point

Ever meet someone so unique that he or she changes your life forever? That's what Bosch did to the art world: With his bizarrely grotesque and imaginary images of Heaven and Hell, he introduced a startlingly new vision to painting—not a new style, or technique, or school of art—but a new *vision* that articulated the myths swirling in the minds of Christians of his time. In so doing, he tapped a universal vein that has spanned cultures and centuries. He was an artist who captured the

Hieronymus
Bosch
Self-Portrait

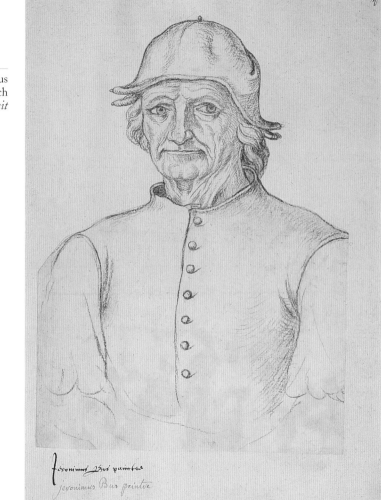

moment in history (and art history) between the Middle Ages (or medieval period) and the Reformation (i.e., the battles between the Roman Catholics and the "protesting" Protestants who sought "Reform" within the Church). The struggle between these opposing religious forces would help strip off the centuries of tiresome ideologies and prepare the way for the fresh, energized *rebirth* of thinking that would unravel during the 16th-century *Renaissance*.

Bosch's off-kilter images—at the same time jubilant and sobering—have resonated so strongly in the psyche of viewers that they continue to delight even in the 21st century, when we elevate humans of genius and originality to the pantheon of celebrities and cultural icons. Why? Because they are purveyors of pleasure. Bosch, a painter of worlds beyond, arouses us with lithe nudes who cavort by crystal fountains in an earthly paradise that is a kind of demonic theme park of Hell, and where oddly cobbled demons cook up humans for dinner. He has been called a religious fanatic, a sexual obsessive, and a drug-crazed lunatic, but in reality he was a respectable, conservative public figure whose art represented religious and social ideas current among his peers.

Off to the Races

And so the story begins: The future artist Hieronymus Bosch was born as **Jhieronmous van Aken**. There is no record of where or when he was born, but critics use the date of October 2, 1453, as a viable one.

THE GREATER
NETHERLANDS

– – – – Present-day Borders

NORTH SEA

NETHERLANDS

Haarlem •
•Amsterdam
Leiden •
The Hague •
•Delft
•Utrecht
UTRECHT
Rotterdam •
•Dordrecht
•Nijmegen
• 's Hertogenbosch

HOLLAND

ZEELAND

BRABANT

GUELDERS

GERMANY

• Bruges

FLANDERS

•Ghent
• Antwerp
•Mechelen
Brussels •Louvain
BELGIUM

LIMBURG

R. Meuse

•Maastricht

•Aachen

R. Scheldt

R. Rhine

We know with certainty that he died in 1516, because there are historical documents that chronicle Bosch's later life.

Bosch lived and died in the small town of **'s Hertogenbosch** (yes, the **'s** is part of the town's name) in North Brabant, a woodland province isolated between modern Belgium and the Netherlands. It was then under the control of the Duke of Burgundy. Records show that Bosch's family lived in 's Hertogenbosch for two centuries under the name of van Aken—a name that suggests they came from Aachen, Germany. When the artist renounced his family name and took to signing the

carefully painted letters **Jheronimus Bosch** on his pictures, it must have been with the aim of calling attention to his native town, 's Hertogenbosch (*bosch*, or "woods," of the *hertog*, "the duke"—i.e., the duke's woods).

The unprepossessing town, also called Den Bosch, was a manufacturing center known for its cloth and metal works. It boasted a Gothic cathedral built after the model of those in France, but otherwise had no claim to fame. The town lay at a considerable distance from the regional centers of art and had nothing to boast about until Bosch came along.

There, Bosch's grandfather, father, and numerous uncles and brothers had all worked as painters. Bosch seems to have spent most of his life in this town. After 1477, with the fall of Burgundy, Brabant became part of the Netherlands.

The business community of 's Hertogenbosch was organized in trade societies or *guilds* whose members worked at a single craft. There was a trade union aspect to the guilds: They were responsible for setting professional standards and pricing for their work; they organized the training of **apprentices** in childhood who became **journeymen** (i.e., assistants) in youth, and eventually **masters** as adults. A licensed master would then take on apprentices, hire journeymen, and contract for production. The guilds could accumulate substantial wealth and often challenged the political authority of inherited nobility. Bosch bought his food and clothing from guild shops of bakers, butchers, and tailors.

Hello, Success!

From 1480 on, Bosch was registered in Den Bosch as a painter, and in 1481 he married a wealthy woman of the town. (Who was she? Why was she wealthy?) Thereafter, he lived with her on an estate that was part of her dowry, and a few years later his name began to appear in the rolls of the pious Catholic fraternity, the *Brotherhood of Our Lady*. He was hugely successful, paid high taxes, and enjoyed the patronage of such nobles as **Margaret of Austria** (1480–1530). His neighbors were largely artisans, members of local *guilds*, which were protective societies that guided the working lives of artists. The guilds produced festive carnivals for religious holidays and helped to establish numerous chapels in Den Bosch's cathedral, the Cathedral of Saint John. In fact, Bosch contributed designs for original furnishings for the cathedral. These social and financial facts are well documented, yet there is no record of his having traveled within the region or abroad.

As the son of a successful artisan family, Bosch was probably educated at one of the Latin schools in Den Bosch. Since he was a contemporary of the printing press, he would have had access to a number of books

Sound Byte:

"Bosch wanted to depict the truth about the beginning and end of time, religious faith, the forms of nature, the supernatural world, holiness and evil, human nature, and more. He was initiated into a religious order during a time when the Church was fighting witches and demons. He was trying to visualize the beliefs of his age about evil beings. Much of his art was made for the rulers of his country, the dukes of Burgundy and their courtiers. They liked extravagant display and were not easily shocked by horror, sex, or obscenity."

—GARY SCHWARTZ, art critic

and ideas that had been previously beyond the reach of the new middle class.

A new Realism

There is nothing in the art of Bosch to suggest provincial awkwardness or naïveté. The new vision he introduced was serious, vast in scope, and sure of itself. However fantastic and unheard-of the things he imagined, he was never anything but heart and soul a man of his time. His lurid fantasies were products of his age, visible evidence of the fear of witchcraft and devilry that obsessed people in the decades immediately preceding the Reformation. What Bosch invented was not very

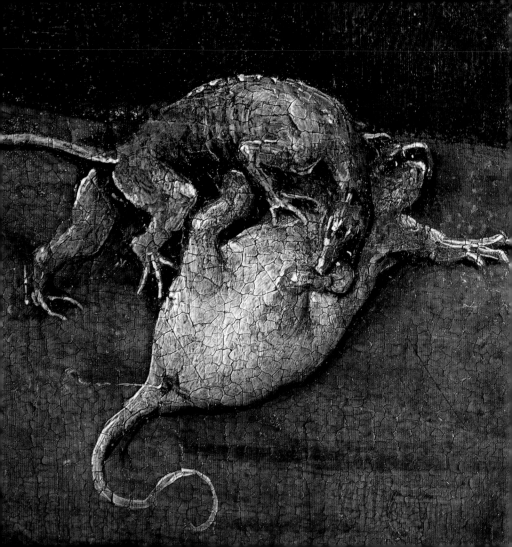

different from what the people of his time in general took to be real. His was not a fairy-tale world, even though much in it took on the guise of fable. The picture he held before the eyes of viewers could easily be accused of exaggeration and falsity, but it was part of his single theme—the fortunes and misfortunes of human existence—a theme cloaked in cryptic language that piled riddle upon riddle but whose basic meaning, once decoded, proves clear and unambiguous. Though he spoke in riddles and fables, Bosch was at heart a **realist**.

But what was the reason for those weird puzzles set down with such striking realism? It was not because Bosch was predicting an apocalyptic end of the world, nor was he depicting a desolate wilderness and barren scrubland as the inevitable final outcome of civilization, as did many of his peers. He was neither a heretic nor an unthinking churchgoer. Rather, he portrayed **sins** (of commission and of omission) and **human suffering** (as evidence of divine wrath or as a burden taken over by the Redeemer) in a way that no longer depended entirely on the descriptions in the Bible and the apocalyptic literature of his time.

Visual images of the *Apocalypse* (i.e., prophetic revelations about a cataclysm in which the forces of good permanently triumph over the forces of evil, as depicted in the "Revelations of Saint John the Divine") and *Last Judgment* took on a very different appearance in Bosch than at any time in the Middle Ages. Before Bosch's day, the delivery of rewards and punishments had been an uplifting, instructional image to be

OPPOSITE
Detail from
*Visions of
the Beyond:
Paradise*
Palazzo Ducale
Venice

contemplated with thoughtful resignation. With Bosch, it became a moralizing representation open to personal interpretation by the individual viewer. The artist showed human evil more nakedly than ever before in relation to the sufferings of Christ. But he shifted this realism to a less direct plane, and in its place populated his world of images with **demonic creatures** that had never before been seen, either in life or in art. Bosch went far beyond the way in which "similar" creatures might have been depicted, for example, in contemporary woodcuts, by creating a total reworking of the representations of evil spirits. Instead of merely presenting the devil as a kind of grotesquely caricatured animal, Bosch showed him as a monstrous hybrid of insects, reptiles, chunks of human anatomy, and bits and pieces of machinery. In itself, this fantastic imagery was enough to drive the traditional Christian content from center stage.

The devilish brood contaminated everything human and real in Bosch's pictures. Certainly his attitude remained Christian, but it contained a healthy dose of skepticism toward human foibles. He brought the **theme of sin and punishment**, still linked only tenuously with the afterlife, down to earth. This explains why, in Bosch's paintings, everything that relates to earth itself seems as if it has undergone some dreadful cataclysm. Storms that slash across his paintings leave destruction in their wake, and though the land itself lies peaceful and untouched, the sense of horror is scarcely diminished.

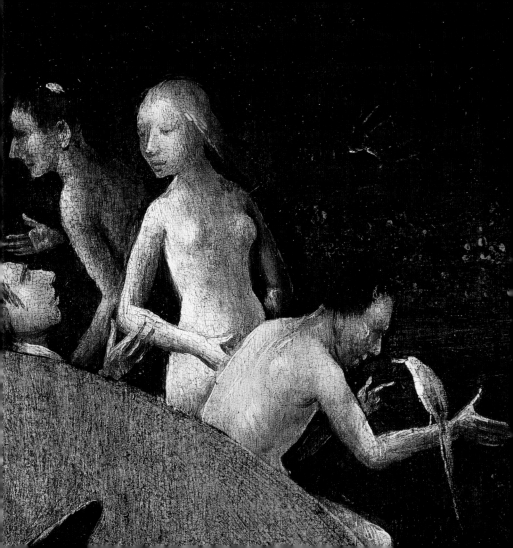

Bosch's realism led him to invent a whole new world of meaningful signs that were effective because of their tendency to deform reality. He no longer spoke the fixed and static language of symbols on which the Middle Ages had relied. In fact, wherever he actually invented something, it was always as unlike as possible what his contemporaries had been used to seeing.

A big part of Bosch's innovation was that these were not symbols in the accepted sense, but explosions of meaning, phantasmagorias designed to lay bare the essence of reality.

The result was a vocabulary of images that seldom drew its symbols out of any existing "stock." Instead, Bosch experimented with possibilities and with symbols that as yet had no determinable significance, but that were rich in suggestion. What resulted was a sudden jolt by something quite inexplicable.

But despite his jarring innovations, Bosch also strikes us as old-fashioned, reaching back as he did to the International Gothic style of the Flemish-Burgundian miniaturists of the early 15th century. He made use of subjects standard in his day—Christ Carrying the Cross, the Last Judgment, etc.—but only after having hacked away everything in them that smacked of the conventional. Though he is a pivotal figure in the history of art, he stood at the frontier between the Middle Ages and the modern era, without giving up the former or launching the latter. He pointed back to the old, but in transfigured guise, and at the same time reached forward into the future, but without piercing the unknown.

The Late Middle Ages (sigh)

Much of our modern world originated in the richly complex culture of the late Middle Ages in Europe from the 12th to the 15th century. It was the age of the great Romanesque and Gothic cathedrals, the

soon-to-be world-famous universities (Oxford, Cambridge, the Sorbonne, etc.), and the Crusades against Islamic Muslims. The transition from medieval to modern culture began during Bosch's life with such events as the invention of printing, the discovery of the Americas, and the recovery of classical antiquity in Renaissance Italy.

Transitional periods are often exhilarating but stressful, as the past does not yield gracefully to an experimental future. Much of medieval life was regulated by orderly rituals of church service, prayer, and social obligations according to economic class. Bells announced the hours of prayer, and costumes identified one's class and rank in the tight hierarchy of society. Every occasion had its public celebration, and privacy was still a desperately new concept of life.

External terrors were real enough: Bosch addresses plagues and civic violence, for example, in *The Seven Deadly Sins* ("Anger"). Internal fears were even more distressing, such as the perpetual state of sin and folly that would lead to endless torment in the afterlife, as painted by Bosch in *The Hay Wain* and *The Last Judgment*. These fears were not prone to rational explanation and alleviation.

Bosch's Training

Critics believe that Bosch's earliest paintings, such as *The Seven Deadly Sins, The Cure of Folly, The Conjurer,* and *Ecce Homo*, were probably done in the 1480s. In these early paintings, Bosch showed a technical

command and style that were already basically formed. There are few hints in these paintings about his origins as an artist, and the records do not mention a teacher.

An art as technically demanding and sophisticated as Bosch's does not spring from unaided genius alone. Some instruction and practical experience were necessary. But where and with whom? Probably at home with his father and uncles in the large van Aken *atelier*, or workshop studio. Bosch would probably have studied five different branches of art and artistic work assumed by contemporary painters: **ornamental decoration**; designs for **liturgical objects** (i.e., for church use, such as stained-glass windows); **wall paintings** (on plaster or on wood); **miniature paintings** (e.g., illustrations in handwritten books); and **easel paintings** (done in oil-based colors on wooden panels).

FYI: **The sequence of his paintings**—The fact that Bosch's paintings are not dated creates some odd consequences. Some critics have attempted to date his works based on a progressive development of realism in them. But this doesn't hold water, since there are less realistic works that clearly belong to the later stages of his career. Bosch's work can be explained only in terms of a unique personal idiom that was a compound of the progressive and the reactionary, of visionary anticipations and reliance on the old-fashioned tried and true.

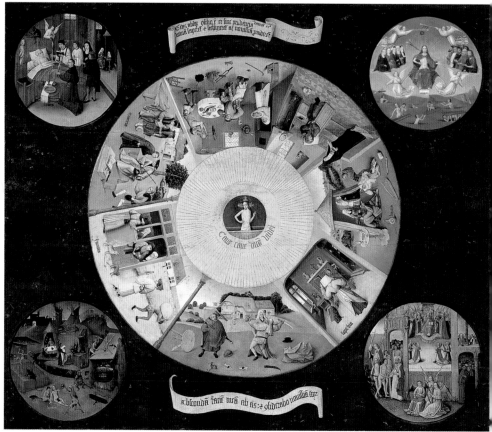

Pointing the finger: *The Seven Deadly Sins*

The world depicted in Bosch's early paintings, as in the television series *Seinfeld*, is a place of ordinary people who are prone to **folly and sin**, and to **excess and exaggeration**. With these two major themes, he never ceased to show how God's benevolent influence on the world was constantly being thwarted by humans. In one of his earliest paintings, the large panel of *The Seven Deadly Sins*, he shows scenes of village life that describe the effect of each sin on human behavior. The painting does not hang on a wall, but rather is painted on a tabletop, with a small round medallion in each corner and, in the center, a sequence of scenes combined into a large circle. The arrangement is old-fashioned, with the kind of distribution of episodes into separate roundels that had been common since the 14th century. But the disk at the center, with its scenes of the Seven Deadly Sins, is more than ornamental. These scenes are the real core and purpose of the picture, more than the roundels with the traditional subjects of the **Four Last Things** (Death, Judgment, Hell, and Heaven). The seven sins make up the iris of an eye in whose pupil we recognize, as we come closer to the table-top, the Risen Christ.

The sin we notice first, and to which the gesture of Christ directs us, is *Anger*. Here, Bosch attacks pigheadedness and obstinacy. Although this is a *didactic* picture (i.e., one designed to teach a moral lesson), it contains the first intimations of the menace that later, in the guise of

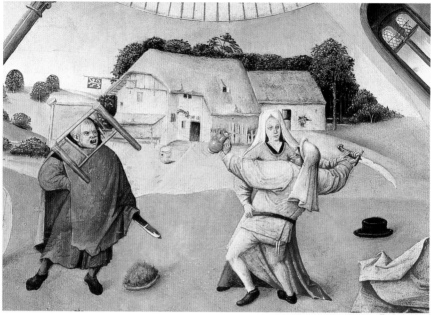

Detail of "Anger" in *The Seven Deadly Sins* 47 ¹/₄ x 59" (120.49 x 150.45 cm)

temptation, doubt, and the ever-waiting trap, will constitute an essential trait of all of Bosch's work. The seven sins are arranged in a circle around an eye. In the center, Christ shows the wound that symbolizes the basic sacrament of the Church. Various inscriptions cite passages from the Book of Deuteronomy XXXII and the warning *Cave Cave Dominus Videt* (i.e., Watch out! Watch out! God sees!). Beyond the surrounding gold-striped sunburst of the iris, the sins are acted out as real-life blunders.

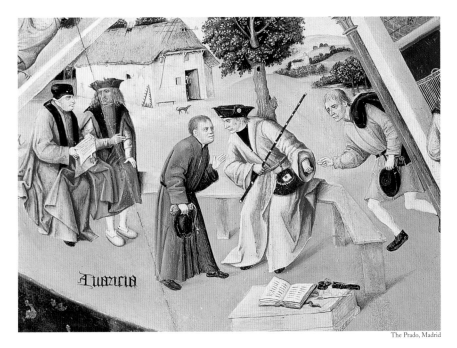

Clockwork of Errors

Reading clockwise from the bottom roundel we see: **Anger** (Latin *Ira*), portrayed as murderous fighting and rape; **Envy** (*Invidia*), as covetous dogs and their masters; **Greed** (*Avaricia*), as a judge taking a bribe (sitting on a bench, as in a modern court, he extends his palm behind him in a gesture called a "porter's tip"); **Gluttony** (*Gula*), a common problem in a world of feast or famine; **Sloth** (*Accidia*), or laziness and neglect of

Detail of "Greed" in *The Seven Deadly Sins* 47 ¹/₄ x 59" (120.49 x 150.45 cm)

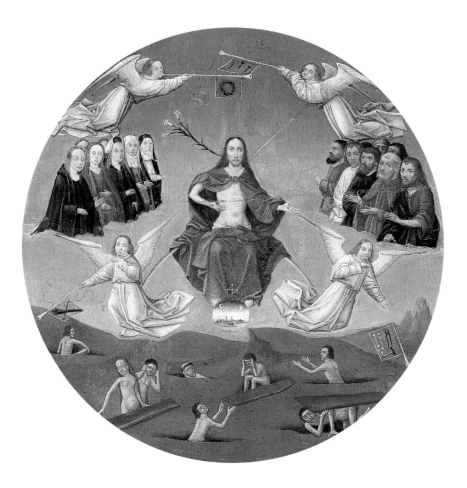

the soul; **Lust** or **Excess** (*Luxuria*), as a party in a tent that recalls medieval book illustrations for romances of courtly love; and **Pride** and **Vanity** (*Superbia*), with the scene of "mirror, mirror on the wall," held by a devil.

Bosch's purpose in demonstrating the outcome of the seven deadly sins was not merely to be satirically amusing. As a devout Catholic, he truly feared for the **fate of the soul** at the Final Judgment.

The Four Last Things—Death, Judgment, Hell, and Heaven—are painted in medallions at each of the corners of *The Seven Deadly Sins*. The compositions are primitive compared with Bosch's later paintings of Hell, but these medallions are essential to understanding the artist's realistic and sharp vision of society.

The Prado, Madrid

Advice to a Fool

The Cure of Folly and *The Conjurer* are two early independent genre scenes related to *The Seven Deadly Sins*. In these works, Bosch shows **two aspects of foolishness**, a less severe failing than the deadly sins but still nothing to brag about. In each, we find further evidence of Bosch's critical view of his neighbors.

The worst threat is **folly**, which often begins as self-deception. The portrayal of ordinary behavior, good or bad, without a literary narrative theme, is called *genre painting* (from the French word for *category*). In Bosch's day, genre was still rare among themes dictated by the Church or taken from history and legends. His early depictions of daily life are an important step toward modern realism.

The Cure of Folly

In *The Cure of Folly* (aka *The Operation for the Stone*), a quack surgeon cuts a small flowering growth from a man's head. This is the stone of folly, but is really a swamp tulip, symbol in Dutch folklore of a costly hoax. In handsome, formal calligraphy, the painting is captioned above and below the picture: "Master, cut out the stone; I am called the Tricked, Cuckolded, Impertinent Badger." The man has given his consent, though he is tied to the chair with a thick band of cloth. One wonders about the nature of his complaint: The consequences of living too well? Is he a madman?

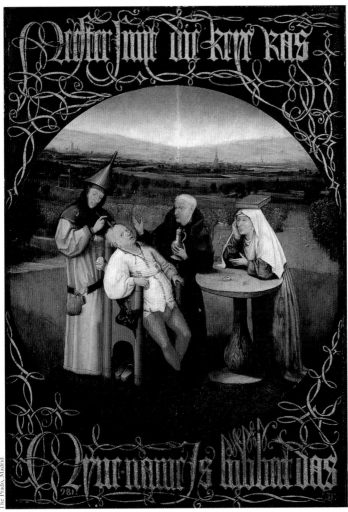

The Cure of Folly
18 ⁷/₈ x 13 ³/₄"
(48.07 x
35.06 cm)

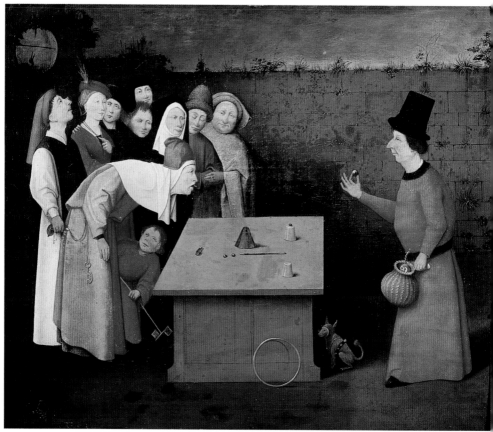

The explanation of the scene lies in the headgear of the quack surgeon and his assistants. The stocky victim appears to be surrounded by individuals who are foolish at best, malevolent at worst. The surgeon wears an inverted funnel, a sign of a blundering choice in hats or a reversal of the proper flow of intelligence—out instead of in. Notice the open wine jug hanging by his thigh; this does not bode well for the patient. The nun resting against the table sports a closed book senselessly balanced on her head, an old allusion to an inability to read or actually understand the book. The monk who addresses the victim holds a pewter pitcher. But what does it contain?

OPPOSITE
The Conjurer
20 $^{7}/_{8}$ x 25 $^{5}/_{8}$"
(53.17 x 65.28 cm)

The painting mocks the ***folly of gullibility*** and criticizes the swindlers and tricksters that this kind of folly attracts. The inverted funnel and book worn as headgear are signals invented by Bosch to warn viewers of booby traps for the gullible. Since the suspicions of the well-fed, and probably well-off, gentleman are not aroused by the fantastic getups, he earns the painter's contempt no less than do the unscrupulous attendants to whom he has fallen victim.

Con Man's Bluff: *The Conjurer*

In *The Conjurer*, Bosch painted an urban counterpart to *The Cure of Folly*. The narrative is simple: Just inside a town wall, a con artist works a shell or bead game on an eagerly credulous dupe who bends his full, dim concentration on something that is not there. Behind him, a pick-

pocket, eyes looking toward heaven, cuts loose the fool's purse. Only the child at his feet grasps what is going on and finds the incomprehensible behavior of the older person more fascinating than the conjurer's surprises. Body movement, gesture, and expression explain everything in this comic pantomime; it has almost no obscure symbolism. The owl in the con man's basket feeds on small prey like his master; the frog on the dupe's tongue symbolizes an old Dutch idiom, "to swallow a frog," which means "to be really dumb." The crane in a nest in the oriole window at the upper-left corner refers to the idle gossip of the passive onlooker.

The style of *The Conjurer* is difficult to assess in its present condition, having been overcleaned and repainted at an early date. This has exposed the underdrawing in the con man's face, where parallel strokes of dark color (a technique called *hatching*) show the original preparation for painting. The hatched lines can be seen in similar places in other Bosch paintings as drawn indications of shadows intended for the final paint layer.

Grounds for Comparison

Although there are few signs here of the evil that will become frequent in Bosch's later paintings, we see already gathered the faces with which we will soon become familiar—some of them bloated while others are stiff and staring, or depicted in a self-righteously "shabby genteel" manner

(among them another nun, as in *The Cure of Folly*). Long, thin noses and narrow, slitted eyes are distinct traits of the faces in this painting and in *The Cure of Folly*. Not one of the people in this painting has a serious thought in his or her head. They are, and want only to be, as happy as the day is long. So the evil that befalls them comes without their noticing—behind their backs. This work is an early example of Bosch's basic pictorial language, which will become richer and more varied as he matures:

- the depiction of striking **facial features**

- the firm **silhouetting of figures**

- the counterposition of a **tight-packed group** and an isolated, attention-fixing point of attraction.

The gullible blockheads watching the conjurer are let off more easily than the hopeless victim in *The Cure of Folly*. But this, too, is a folly that can spread and turn nasty. Here, we have only a confidence game, but the trickster who runs the show is one of those who know how to palm off lies as gospel truth, who go on from small prey to bigger game—the game that ends up in backbiting and ill will and aggression that leads to all hell breaking loose.

With no fixed chronology for Bosch's paintings, we have no choice but to scour each work to see if perhaps there are signs of a beginner. The latter almost always has to do with *form* as such, since its sign is a certain

monotonous flatness that only gradually becomes enlivened. The three pictures mentioned so far all have this flatness to one degree or another. As we begin to grasp just how that style developed into a virtuoso juggling with colors and finally into a sublime serenity in workmanship where all effort is concealed, we find that almost without knowing it we have arrived at a series of criteria that make sense. While it was no innovation that Bosch painted profane subjects, he did infuse them with liveliness and a feeling of significance, giving each its own unique facial features. In so doing, he created an art uniquely his own, one he was able to carry over into the Christian subjects that, for him as well as for his contemporaries, were his chief concern.

A Trial in Town: *Ecce Homo*

By the time Bosch painted *Ecce Homo* (Behold the Man), in which Pontius Pilate presents a stripped and exposed Christ to the people, he had evolved a subtler use of his narrative devices. Here, elements of the composition create an abstract stylistic commentary on the subject. The foreground is divided by the rising diagonal of the masonry parapet on which the condemned Christ, crowned with thorns and lacerated from head to foot, bends in supplication to a jeering throng. The mob presses forward, bursting with the hostility of those who mistake their inflamed passions for righteous sentiments. The resulting isolation of Christ from His tormentors is one of numerous contrasts that Bosch now develops to engage **realism for expressive purposes**.

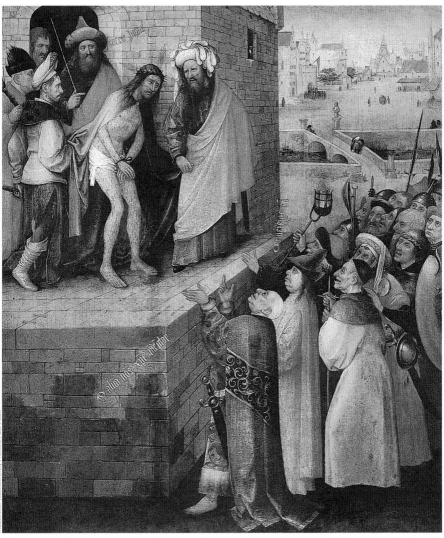

Other contrasts include:

- A massive building and background open space

- Pilate's heavy robe and Christ's naked limbs

- A grid of lively mortar lines and arabesque ornaments on clothing and weapons

- Color that alternates in full ranges of greens and reds

- Christ's gentle stare and the ugly anger of the mob.

In the background, an entire town lies just beyond a small bridge. Like the town of Den Bosch, it has an ample public square with a central cathedral, private homes, and a fortified municipal building. On the bridge, a small couple stares down at the water, oblivious to the remarkable events that we see.

One innovation here, to be carried much further in Bosch's later works, is the portrayal of **the crowd as a mob** incapable of judgment and inclined to every bestiality, as long as there is the safety of numbers. Even when the mob succeeds in masking its members from appearing as individual monsters, it collectively signifies the living proof of human guilt, and therefore offers something realistic.

Another innovation is seen in the marketplace in the background, a peaceful hinterland that is no longer a mere accessory to the scene, but

that instead has the significance of an untroubled place where humans no longer recall the dire events pictured in the foreground. This is how Bosch sees the world: It is a place divided between the caring and the uncaring.

Even when one would least expect it, Bosch infuses the conventional themes of the life of Christ with an unrest entirely without precedent. In an early *Adoration of the Magi* (not to be confused with the larger, greater painting of the same name made later in his career that now hangs in The Prado in Madrid), some of the gestures strike us as over-wrought, others as puzzlingly standoffish, and all of them as remote from the richly ceremonial character of this scene. Probably no episode in the childhood of Christ was painted more often in the 15th century than this one, in which the secular power, with all its exquisite and costly trappings, is brought face to face with the Holy Family. Although the family is shown in a poor country place, they retain much of the aura of the long-traditional devotional image.

Yet Bosch introduced a serious alteration here: We no longer have the subtle and intricate interweaving of figures, the elegant crumbling masonry, and the gentle stretches of landscape that his predecessors had painted. The place is more like the entrance to a mine pit, the house deteriorating and forlornly surrounded by a decaying gray wall. The king clad in gold-green offers the Child a many-cylindered chalice. Joseph is placed behind a table (another innovation) and, gazing upward,

The Adoration of the Magi
30 ¹/₂ x 22"
(77.8 x
56.1 cm)

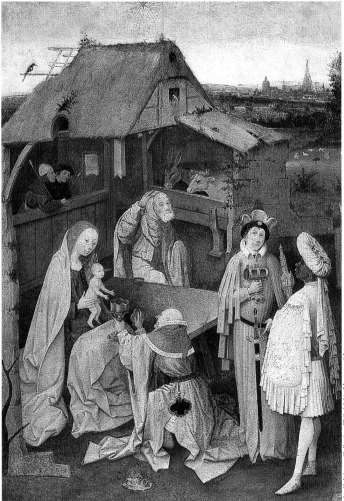

anchors the exact center of the painting. He and the kneeling king catch the eye by their almost ecstatic gesticulating movements.

Almost nothing happens in this work, but already we see that sharp, intense, searching sort of form that will be found in all the future fantasies of Bosch. It is astonishing that the other two kings stand entirely apart at the right, untouched by any agitation. They are the clearest demonstration of how everything in this picture is kept remote from everything else, and yet at the same time held in mutual attraction. Notice that, embroidered on the left sleeve of the Moor, is the scene of the Israelites gathering manna in the desert. This is one of the frequent artistic devices that Bosch will use in later works: He ingeniously works a second picture into his main painting, in this case to convey an Old Testament allusion to the coming of Christ and to the sacrament of His sacrificial death.

Alone in a Crowd: *The Wedding Feast at Cana*

As Bosch's technical capacities grew, he increasingly painted scenes involving crowds. Note the active interrelationship of individuals within a compact group, their distinguishing gestures and facial types and expressions. Despite problems of poor preservation, *The Wedding Feast at Cana* (see page 41) stands at the threshold of Bosch's middle period. It contains elements found in the first genre paintings of the vices, but its ambitious composition manages the placement and individualization of 21 figures, which is no mean task!

The basis of the composition can be traced to a formula found in large *frescoes* (i.e., wall paintings done directly onto damp plaster and allowed to set) from the 14th century in the northeastern Italian city of Padua. The Florentine painter and architect **Giotto di Bondone** (c. 1267–1337) used for the first time, in his *Wedding Feast at Cana*, the unusual device of an L-shaped table as a way to gather many figures in a single coherent place. This clever device did not really survive into the 15th century as a compositional solution, either in Italy or the Netherlands. So how did Bosch learn this style of "bending space" within a picture's confines? Either he knew something of the Italian prototype, or he "invented" it independently. But how? Bosch rarely traveled and there is no record of his having made a trip to Italy. It is more likely that a small work, such as a miniature painting or even a drawing in a "model book" carried by Bosch, conveyed this idea to him.

Even though the composition may be international, Bosch's treatment of this interior and its cast is strictly local. He takes obvious pleasure in depicting opulent and finely made decorations. This can be seen in the gilded stool before Christ, with two saints on painted insets and a pearl border, and also in the gold cloth hanging behind Christ. Very fine pliable wires of metallic gold were actually woven into the cloth.

Ostensibly, the theme here is Christ's miraculous transformation of water into wine, but it is not clear what is really happening. In the background, you'll see a sorcerer's altar, and among the dishes being

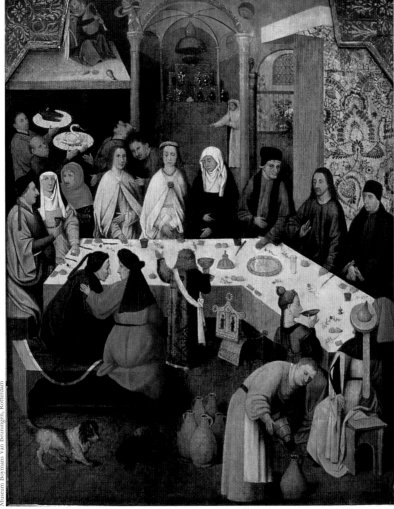

brought in is a swan spewing smoke. That the assembly seems bowed down or even depressed, as hardly befits the circumstances, must surely be due to these mysterious goings-on of a sort that was to become a frequent feature of Bosch's later works, and which leads us to the frustrating (and eventually hopeless) task of trying to explain what the artist had in mind.

The Hay Wain

Even at a glance, it would appear that *The Hay Wain* has to do with the pursuit of happiness. Surely there is no real reason why human striving, even if it is only for what all humans need—money (or, in Bosch's metaphor, hay)—should not always be crowned with luck and happiness. But we live in a topsy-turvy world. What Bosch paints in this work is greed, not happiness.

He locked this painting into a form—the **triptych**—that once served the purposes of devotion but that, in his hands, became a vehicle for teaching and preaching. He did not, however, disrupt the essential character of the altarpiece. His triptych is a three-paneled work in which the left and right panels are actually hinged shutters that close over the main panel. When the triptych was closed—which is how it appeared each year for six weeks during Lent, a time of abstinence and austere atonement leading up to Easter—one saw the painting that Bosch had created on the backs of these wings. Entitled *The Itinerant*

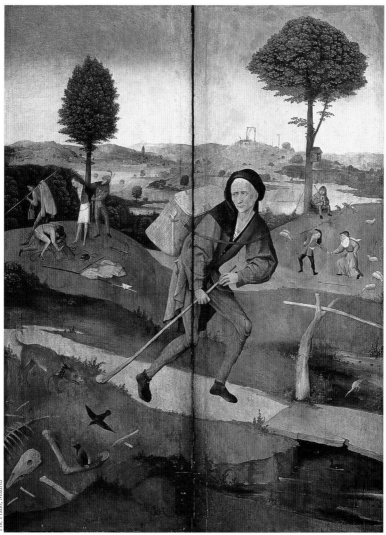

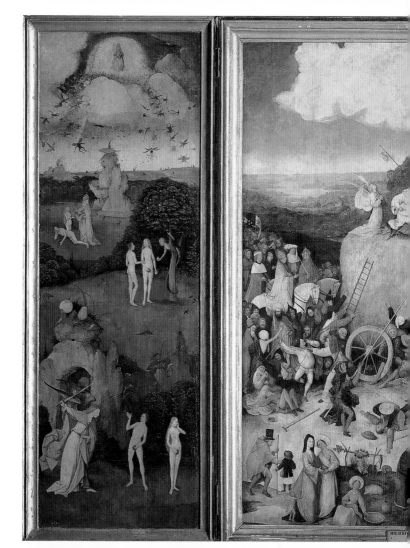

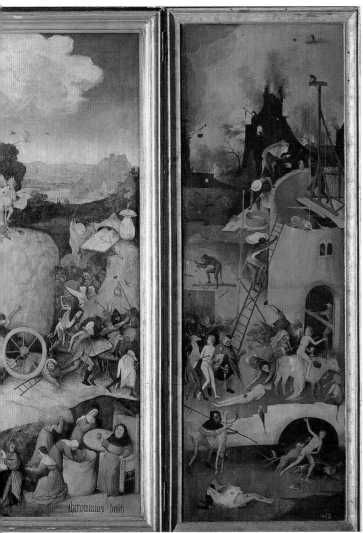

The Hay Wain
triptych. Wings
53 ¹/₈ x 17 ³/₄"
(135.58 x
100.47 cm)

Jheronimus bosch

Peddler, it is a pessimistic image of a sad-faced, ragged vagabond staggering through a dispirited landscape of robbery, lechery, and sloth. The peddler flees in panic from this depravation because, in the background, a man is being attacked by robbers, while not far away others entertain themselves with no concerns for other people. The countryside seems strangely empty and barren, strewn with things that speak of fear. Is it any wonder that the artist implies **the need for Christ's intervention** here? The scene is acted out as vignettes by familiar cast members from *The Seven Deadly Sins*: **Envy**, the dog baying over a carcass, and **Anger**, the gallows on the horizon.

Sound Byte:

"The difference between the pictures of Bosch and those of other masters consists, in my opinion, in the fact that others mostly paint Man as he appears from without, whereas Bosch shows Man's inner nature."
—FRAY JOSÉ SIGÜENZA, c. 1540

In this composition, Bosch's skills as a **landscape painter** serve him well. Individual vices are enacted on small swells of land, each overlapping the next as they move back in space. Realism is necessary in this setting to locate the sins in the actual world of the viewer, which in turn sets a premise for the interior theme of the main panel.

When the wings of the triptych are opened and we see the central

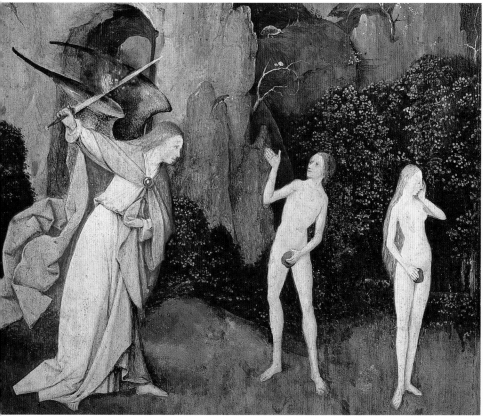

panel, we sense that here, too, the same harsh wasteland will take over once the passing hay wain has moved out of the picture. In terms of composition, what was once a perfectly respectable pictorial form with an easily recognized center has been set into movement here and turned upside down: What was secure and trustworthy has been replaced by delusion.

The open triptych offers a great panoramic cycle that begins on the left panel with the history of the Garden of Eden: the Creation, the Fall, and the Expulsion of Adam and Eve. Each episode follows closely the text of Genesis or a medieval retelling of it. The hay wain rolls across the landscape between the betrayed Eden and the dreaded Inferno. Pursued by armies carrying the flags of Burgundy and the Austro-Spanish Empire, it is pulled by demonic creatures toward their cousins on the right wing. It rolls over and through a brawling crowd, and passes along a roadside gathering in the foreground of quieter vices and small virtues. On top of the haystack, two couples make music and love between a praying angel and a trumpeting demon. Christ looks down from heaven to the angel, His arms raised in a traditional gesture of supplicating prayer much like despair.

Before ever picking up his brushes, Bosch had obviously seen around him the forces of destruction and decay. For truth's sake, he painted lies and folly and frenzy and malevolence and brute violence. Even before we come to Bosch's entirely new vision of *The Last Judgment*, here

already we see him bringing humans to judgment, though it is only in earthly terms. The wings of the triptych show the reason for it all and the consequences. The original sin in the Garden of Eden still leaves the way open to hope, and Hell is not a bottomless pit but a tower still under construction and more like some building set afire on earth itself. This is **Bosch's first large and complex visualization of the Inferno**, seen here as a flaming world staffed by demons pieced together from birds and reptiles, rodents and people.

When our eye is drawn back to the jumble of human delusions in the central panel, we find that the greatest self-deceivers are the lovers, those foolish souls who fancy themselves safe at the very top of the haystack. True, Christ directly overhead looks down on this anarchy like an uninvolved observer. To that extent, the painting is a sermon pronounced by a skeptic, a finger pointed against Christians rather than against Christianity. Once he had ventured into this topsy-turvydom, Bosch was to remain there for many years to come.

FYI: **Voyage of life**—The "voyage of life" was a common theme in medieval literature and dealt with the adventures of the soul in a sinful world. As a literary genre, the voyage of life survived into the 17th century in such works as John Bunyan's *Pilgrim's Progress*, a Puritan treatise written between 1678 and 1684 that was once almost as well known as the Bible in Protestant England and the American colonies.

OPPOSITE
Death and the Miser
c. 1485–1490
36 ⅝ x 12 ³/₁₆"
(93 x 31 cm)

Given the broad premise that life is brief, mercurial, and fraught with danger, we recognize the familiar cast from *The Seven Deadly Sins* as they appear on the larger, crowded stage of *The Hay Wain*:

- **Ira:** There are at least three murderous assaults in progress.

- **Accidia** (i.e., individual sloth): The monk on the right is lifted from *The Seven Deadly Sins*.

- **Luxuria:** Lust and excess are the couple atop the hay; the demon playing his nose as a trumpet has a peacock's tail for vain luxury.

Skeletons in the closet: *Death and the Miser*

Bosch grew more sophisticated in the treatment of his favored themes as he began to mature as an artist. In *Death and the Miser*, probably done in the early 1490s, he demonstrated more self-confidence in presenting his theme that "no one escapes death." He also showed a greater daring in inventing monstrous creatures. Pointed, gaunt,

harassed faces give the first hint of this: The dying man and the one rummaging through his strongbox are one and the same person. In either guise, they flipflop between sanctimoniousness and greed without ever noticing the bloated monsters lurking in every corner.

Here again we see the Four Last Things: Death, Judgment, Hell, and Heaven. But a simple comparison with the deathbed scene in the roundel on *The Seven Deadly Sins* shows a great difference: There, the dying man is surrounded by familiars and priests in prayer, whereas here he is abandoned to his own choices. The angel pointing the way to Heaven has just as little hold over him as the gray devil who pops up from under the bed curtain to offer him a sack of gold: He has eyes only for the arrow that Death points at him from the half-opened door. A miser is dying, but the weak and indecisive movements of his arms and hands make it all too evident that he is the last to understand that even now it is not too late to **choose between damnation and a friendlier afterlife**. Everything here seems slippery and unsure. Is this not the same man, but at that earlier age when he held his beads with one hand and with the other

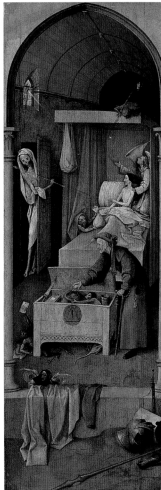

stowed away his gold in a chest propped open by a dagger? And, by the way, *what's going on with the money chest at the foot of the bed?*

This tall, narrow picture was probably a wing of a lost triptych, perhaps an exterior panel. The angular space and muted colors of the window-less room now affect the emotional impact of the subject. Here, more than ever before, *hatching* (i.e., the use of parallel, diagonal brushstrokes) is used as a means of shading. Unlike the shallow, utilitarian interior setting for Vanity in *The Seven Deadly Sins*, this narrow chamber has a frightening aspect: It recedes on a steep, rising angle into deepening gloom, made all the more threatening by Bosch's adroit use of a basic color contrast. The expressionistic color of a green coat and brownish-reddish bed drapery says it all: Nothing here is peaceful, harmonic, or calm.

The excellent condition of *Death and the Miser*, which conservators at the National Gallery in Washington, D.C., restored in 2000, allows us to make several observations about Bosch's working methods:

- A **drawing was sketched** onto the panel first as a guide.

- **Shadows** are indicated by hatching, which mostly runs from upper left to lower right.

- Color glazes are **thin, translucent washes** applied over the light-colored panel and underdrawing, giving the colors an **inner glow**.

Bosch in bloom: *The Ship of Fools*

The beginning of Bosch's artistic maturity can be seen in *The Ship of Fools*, the last of his early series of instructive genre scenes that deride sin. The basic sin is the all-too-familiar Gluttony, but both his setting and the details of the painting show a marked advance in skill and imagination since *The Seven Deadly Sins*.

Like the ship, the entire painting—inspired by a Netherlandish poem from 1413—is afloat in liquids and is an expression of Bosch's newly found delight in bizarre alterations of the usual dimensions of things. It is hard to say if this unseaworthy vessel drifts in a shallow inlet or on the open sea, though that uncertainty is partly due to the much-obliterated state of color in the background. Since the panel is high and narrow, it too would have been part of a diptych or triptych now lost.

It's anyone's guess what Bosch had in mind when creating this work, but the boat may refer to a variety of ideas: The guilds (see page 12) had boating parties, particularly in May; in Bosch's day, asylums occasionally housed patients on barges floating along the canals; and the **Catholic Church** is often represented as a ship (the living mast enhances that connotation here). While the picture contains no allusions to the Bible, the monk and nun nonetheless make up the central focus of the satirical work. It remains unclear whether the monk and nun are singing to each other or, with others of their silly company, are bobbing for the

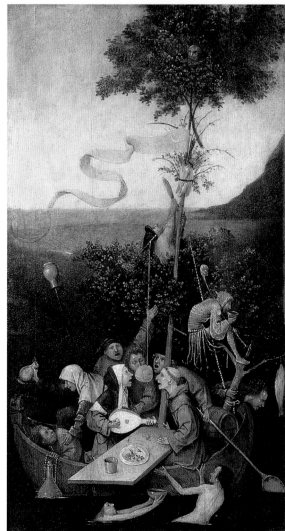

The Ship of Fools
21 $\frac{7}{8}$ x 12 $\frac{1}{2}$"
(55.72 x 31.9 cm)

pancake that dangles between them. (The pancake is a symbol of the Shrovetide feast on the night before Lent.) Regardless, nothing here is to be taken as realistic. Everything becomes a sign alluding to something else: the swimmers, the fool on the mast, the man losing his dinner overboard, the one who crawls about in the bottom of the boat with a huge jug on a cord and over whom a woman is leaning—none of them can be taken as literal or real. Is the subject gluttony or lunacy?

The painting is a riddle composed of ordinary, everyday acts and gestures. The people depicted in it are simple folk, yet the work is full of puzzles. Here, Bosch shows us everything from the outside. Outwardly, everything looks clear and unproblematic. But the boat itself is no longer seaworthy. Is it really under way, or merely becalmed in a swamp alongside a bush out of which a robber clambers up to cut down from the mast a chicken all ready for roasting? But both bush and tree grow in the boat itself—another topsy-turvy world where the things and people are foolish, mad, and unwholesome. From the top of the mast-tree glowers an owl—or is it an impaled head?

Sound Byte:
"I say nothing about the vast height of your churches, their immoderate length, their superfluous breadth. For God's sake, if men are not ashamed of these follies, why do they not at least shrink from the expense? What do you monks do with gold in the monastery, when you do not feed the poor?"
—SAINT BERNARD OF CLAIRVAUX (1090–1153),
lamenting the ornamentation of churches

The Christ paintings

While most of Bosch's paintings deal with matters of Christianity—
the New Testament, sin, judgment, and so on—many of his paintings
focus specifically on the birth of Christ (e.g., *The Adoration of the
Magi*), on His life (*Saint Christopher with the Christ Child, Saint John
the Baptist in the Wilderness*), and on the cycle of the **Passion**, which
refers to the end of His life, with the trial, judgment, and crucifixion
(e.g., *Ecce Homo, Christ Before Pontius Pilate, The Carrying of the Cross*).
Since the paintings are not dated, we have no way of knowing in which
order they were painted, but it is likely that they were *not* painted in the
order that these events occurred in Christ's life.

Quick Rehash: Roman Catholicism

Understanding the details of Roman Catholicism is the key to grasping
the meaning of these paintings. Within the Catholic Church, priests
perform the ceremony of **mass** as a reenactment of Christ's sacrificial
death for the sins of humankind. The ceremony takes place at an **altar**
that contains precious **relics**, which are real pieces either of the body
of Christ or of a saint, or of something they have touched. (In Bosch's
church, there were approximately 50 such altars containing relics from
about 80 saints.) Christians pray to saints as well as to God for assis-
tance during their lifetime as well as for the afterlife. Each saint has a
"specialty," so if, for example, you seek protection from sudden death,

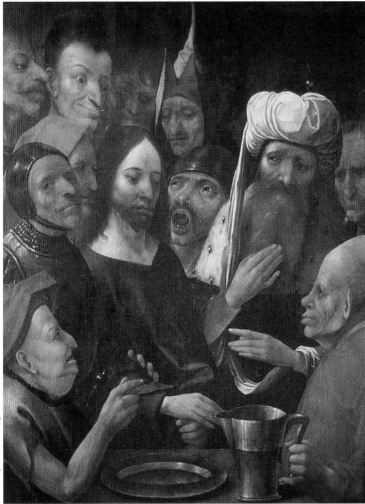

*Christ Before
Pontius Pilate*

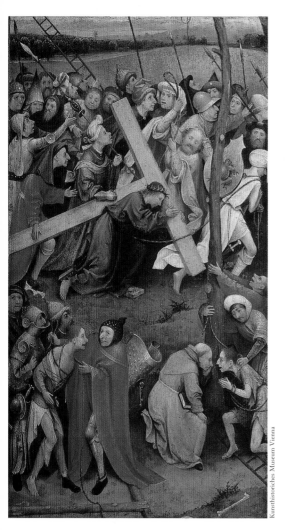

you pray to Saint Christopher. Each person has a **patron saint** who carries the same name and on whose "day" he or she was born.

Dead Man walking: *Christ Carrying the Cross*

At least two superb Bosch paintings of the Passion survive today, both entitled *Christ Carrying the Cross*. In one version, which hangs in the Kunsthistorisches Museum in Vienna, Christ is centrally isolated under the weight of the cross, though a crowd of figures lurks behind the cross and below Christ. **Each face is unique** in type and expression, with little use of exaggeration or caricature. This points to Bosch's growing powers as an observer and realistic artist. Only two symbols are given in explanation for this drama: the dead tree on the right is the *arbor mala*, the Tree of Evil, that will never bear fruit; and

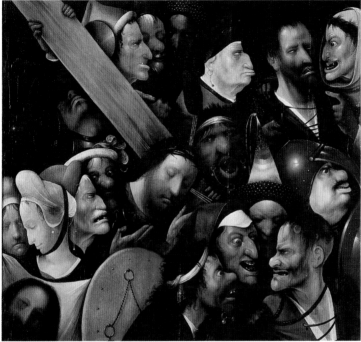

LEFT
*Christ Carrying
the Cross*
29 $\frac{1}{8}$ x 31 $\frac{7}{8}$"
(74.33 x
81.22 cm)

OPPOSITE
*Christ Carrying
the Cross*
Altar wing
22 $\frac{3}{8}$ x 12 $\frac{1}{12}$"
(57 x 32 cm)

the dead frog on a shield bisected by the tree identifies the hoard as a demonic troop.

In another painting of the same theme, the one that hangs in the Museum voor Schone Kunsten, in Ghent, Belgium, Christ is nearly suffocated by a crowd of bedeviled, crudely malevolent taunters who

are oblivious to his suffering and eager for violence. Note their faces: Bosch excels here at depicting the grimy, animalistic persona of the mob as a unit.

OPPOSITE
*Saint Julia
of Corsica
on the Cross*
Wings 41 x 11"
(105 x 28 cm)
Central panel
41 x 24 ³/₄"
(105 x 63 cm)

FYI: Two aspects of Bosch's art continue to be used today in the movies: (1) the sustained close-up of faces in a crowd that establishes the character of a mob, and (2) the casual disregard of an important event by a busy crowd. Filmmaker Alfred Hitchcock, who trained as an artist himself, used both devices with great skill in many of his movies.

This 'saint all, folks

Bosch also grappled with the technical challenge of painting individual saints in deep landscape settings. A series of paintings devoted to the saints traces the main steps in this development of Bosch's art during the 1490s. These works feature Saint Jerome, Saint Christopher, Saint John the Baptist, Saint Julia of Corsica, and others. Whereas in the Passion scenes Bosch needed to establish a multitude of details within the enveloping masses, in the "saint" paintings he creates a large, single form that must be integrated into the vast open space and atmosphere of a realistic vista. These paintings are an essential part of Bosch's frequently overlooked contribution to the development of natural realism in landscape art.

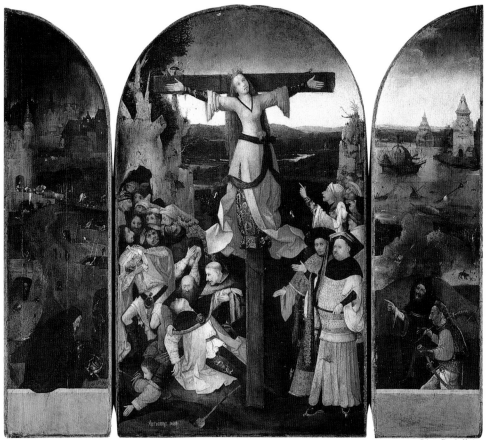

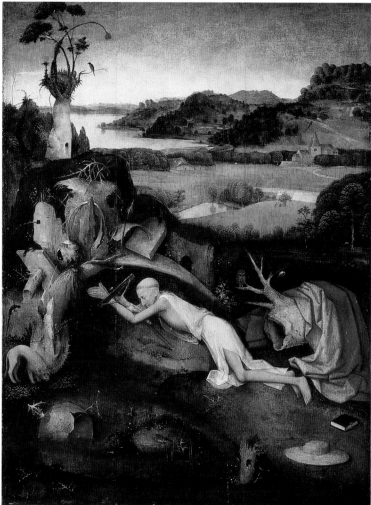

*Saint Jerome
in Penitence*
30 ¹/₄ x 23 ¹/₄"
(77.14 x 59.3 cm)

Museum voor Schone Kunsten, Ghent

Saint Jerome prostate

In *Saint Jerome in Penitence*, Bosch tried to overcome the awkward middle barrier found in some of his earlier works by:

- Lowering the hill and joining it to the foreground

- Absorbing the prone figure of Saint Jerome in the rise of the foreground hill

- Showing the fore- and background from the same vantage point.

It almost works, except for the sudden change in the scale of objects from front to back. Monsters are absent, but rank weeds, tree roots, and the Burgundy-red, half-burst-open peeling of a fruit lying in the water are enough to tell us that this is wasteland.

> *FYI:* **What's in a name?**—The patron saint of Hieronymus Bosch was Saint Jerome. "Hieronymus" is the Latin form of the name "Jerome".

Saint Christopher and the Dragon

The daily experience of life in the late Middle Ages was physically extreme. Light and dark, heat and cold, feast and famine, health and disease—there was little that could soften their contrasts. Silent woods, church bells ringing the cycle of daily prayer, and sly whispers and

sudden shouting were all publicly known and shared. There were private sorrows known only to the injured party, industrious gossips, and their audience: adultery, miscarriage, and strangely disquieting digestive problems. The calamities of floods, wasted crops, and outbreaks of plague were caused by the dragons and giant snakes living in caves, in marshes, and by the river banks. Everyone knew this.

In *Saint Christopher Carrying the Christ Child*, Bosch extended the vantage point and scale of the background right up to the front of the picture. This works out as a consistent, unbroken recession without a separate foreground stage or middle-ground barrier. It is a pity that the legendary giant Saint Christopher has been banished from the ranks of authentic saints. As an early convert to Catholicism, this saint ferried people across difficult rivers, safe from drowning and dragons. He came, thus, to take the Christ Child on his back, for which he was commemorated as one of the Fourteen Helping Saints until his official status began to fade under rational scrutiny in the 18th century.

To Bosch, the value of the saint lay not with *reason* but in the reasons identified by the dragon's presence. The altar might have been intended for prayers against plagues, or against flooding—no small problem for the bargemen who moved much of the production of 's Hertogenbosch to larger markets along the canals and rivers of the Netherlands.

This single, bird's-eye view serves the legend of Saint Christopher well. The immense saint, his brilliant red robe flying, wades through—

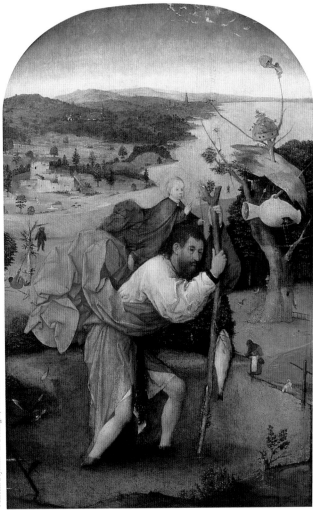

*Saint Christopher
Carrying the
Christ Child*
44 ¹/₂ x 28 ¹/₈"
(113.5 x 71.8 cm)

not merely in front of—the blue-green river. Bosch helps us grasp the magnitude of Saint Christopher's size by depicting the figures on the riverbanks as small beings.

Except for the slightly oversized Christ Child, the landscape here is a marvel of empirical observation: It is a convincingly real vista depicted from a high vantage point and contrived entirely by the artist's eye through deduction, without a geometric guide. One wonders if Bosch drew the landscape from the tower of Den Bosch's Cathedral of Saint John to achieve this view.

The landscape is so convincingly real that the viewer takes many potentially symbolic references in stride. A bear is hanged by a hunter along the riverbank, and a dragon rises behind a ruined wall on the far shore, dangers evaded by the giant saint. (The giant fish on Saint Christopher's staff is derived from another part of his legend and is his *emblem*, the object by which he can always be identified.)

The dead tree with its inhabited, broken pot on the right is far stranger, and may refer to a biblical or local proverb. In Corinthians I: 7–20, people are admonished to remain content with their status in life. In 15th-century proverb lore this translates as "To dwell in one's calling." Quite literally, this might caution the local potters to live within their means. The fellow at the top of the tree is robbing honey from a bee-hive, another reference to shirking one's duty.

Saint John and Natural Unity

Bosch explores another aspect of the landscape problem in the painting *Saint John the Baptist in the Wilderness*. Here, the note of evil is struck simply, by a single plant in the greensward: A thistle bearing a pomegranate grows out of a narrow cleft, as much the signal of a moment of terror as the pile of flapped and lidded caves and stone slabs in the background. Again, the subject dictates a landscape setting, which is again given as a deep vista seen from above. The problem of the middle-ground transition remains only partially solved, although Bosch now shows great skill in integrating the figure of the Baptist, the hill and ledge on which he reclines, and the very strange tree growing up, across his body, through the middle of the composition.

The tree and its fruit probably refer to the nourishment of the *arbor bona*, the good tree of paradise. Its exotic type appears again in Bosch's later and largest paintings. The attention of John the Baptist on a quiet lamb is straightforward and reassuring: This is the lamb of God, symbol of both Christ and the Baptist.

The big forms in the foreground seem keyed together as a continuous mass, an impression increased by Bosch's new use of darker colors, richer shadows, and a soft atmospheric tone in the distant landscape. The increased introduction of atmospheric perspective—a gradual dimming down or hazing over of colors as they recede—is an empirical

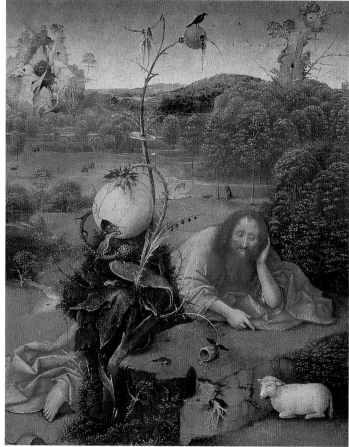

*Saint John the
Baptist in the
Wilderness*
19 ¹/₈ x 15 ³/₄"
(48.8 x 40.2 cm)

compensation for the lack of linear perspective with its geometrically planned angles of recession.

The World Series: The Triptychs

The smaller paintings from Bosch's early and middle years show his increasing command of social realism in his genre studies and of natural realism in his landscapes. A few small demons and exotic plants break through in an otherwise quite familiar world, and little suggests anything untoward beyond.

Then we turn to the series of large triptychs—three-part paintings akin to the three books of a literary trilogy— and everything seems to change. These works include *The Temptations of Saint Anthony*, *The Last Judgment*, and *The Garden of Earthly Delights*.

Bosch's triptychs painted in the decades just before and after 1500 are a unique entity in the history of art. They define the artist's reputation as a painter of the strange and otherworldly, of the near-Surrealistic. They harbor mysteries of theme and purpose and symbolism, and attract us on aesthetic and imaginative levels:

- Triptychs were expensive undertakings.

BACKTRACK
LEONARDO DA VINCI
(1452–1519)

Like Bosch, the contemporary artist and scientist Leonardo da Vinci tackled the placement of figures in or before a landscape. His unfinished *Saint Jerome* of about 1483 (Rome, Vatican Gallery) uses a high rocky ledge to separate the saint from the distant landscape. Nor is there a middle ground in the *Mona Lisa* (Paris, Louvre), painted 20 years later. Instead, Leonardo used *sfumato*, Italian for "smoked or hazy modeling," to make the landscape look far away behind the figure.

- Each was commissioned and paid for by donors, who included nobles, church orders, and guilds.

- Triptychs were intended for public display and needed to be readily understandable to their intended audience. (Bosch's audience would have been devoutly Catholic.)

- Many symbols that are obscure to us today were based on local customs and expressions that Bosch's contemporaries would have understood.

Despite the seemingly alien array of plants and creatures in the triptychs, their basic themes are usually fairly conventional. Indeed, demons are the natural population for the scenes of Hell that appear on the right-side wings of three of these triptychs. And demons are fundamental to the theme of two of the major triptychs: *The Temptations of Saint Anthony* and *The Last Judgment*.

Field Of Bad Dreams: *Temptations of Saint Anthony*

Saint Anthony (251–c. 350), an Egyptian hermit, was the father of Christian *monasticism* (i.e., a life spent in retreat from worldly concerns). A colony of hermits grew up around him and he ruled them as a community before going away to the desert, where he resisted the many temptations of the devil. The feast of Saint Anthony is celebrated on

January 17th. *The Temptations of Saint Anthony* depicts the temptations that Saint Anthony undergoes while alone in the desert.

On the outside panels of the closed triptych, the exterior wings are painted in *grisaille* (see **FYI** below) that gives a vivid, gleaming rendering from which color is absent, even though pure light—the essence of all color—remains.

> *FYI:* **Grisaille**—When some painters use the color gray, it is always harsh and cold. With Bosch, even in representing dust and desert, some trace of color still comes through. Bosch invented a gray monochromatic painting called a *grisaille* (from the French *gris* for "gray"). On occasion, he used grisaille to represent life reduced to its minimum qualities. Or, he used it when it was mandated that the wings of a triptych be closed (e.g., during Lent) so that no color appeared on the altar. This made the triptych acceptable for a Catholic altar.

This is a picture whose strangeness is due in part to its ever-changing and disconcerting landscape and architectural settings. It is impossible to be certain where one is or why one should be there. The only thing certain is that we are seeing three experiences undergone by Saint Anthony during the years he lived as a hermit, from the end of the 3rd century until well into the fourth.

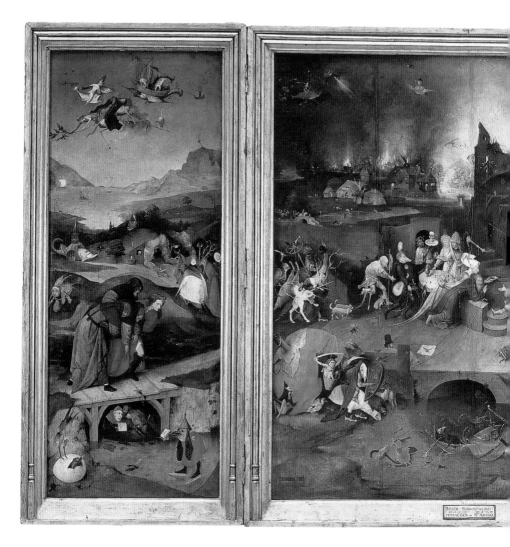

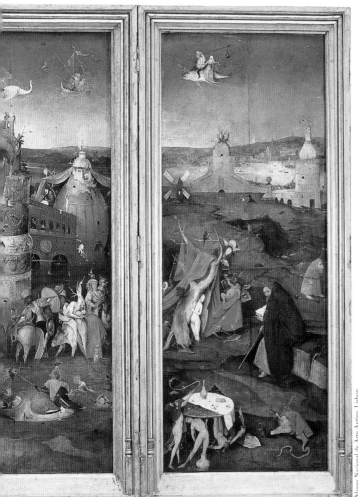

The Temptations of Saint Anthony Triptych. Wings each 51 5/8 x 20 7/8" (132 x 53.28 cm) Central panel 51 5/8 x 46 7/8" (132 x 119.5 cm)

Inside the triptych, a continuous landscape background that moves from far left to far right, across the three panels, unites three separate episodes of the saint's hallucinatory tribulations in time and place. One should not flatly label the subject of this painting as the world under the sway of evil. This would imply that Bosch was merely illustrating sorcery and humans' fear of demons. On the contrary, he exposed all unholy practices as contemptible. In so doing, he held to the idea that the much-beplagued Anthony proved his strength through self-control.

The theme of temptation itself has a double meaning not to be over-looked in this picture: **Temptation, by its nature, always leaves in suspense what is yet to come and who is to be the ultimate victor.** The composition is most ingenious in those places where it involves wrecked, decayed, half-defined forms swept away like detritus. Thus, the real meaning of the painting is this: Nothing works out the way it should because human misery and vain ambition raise their ugly heads, and out of both comes evil, though evil itself is not yet present.

The three interior panels have landscapes filled with all sorts of covered, hollowed-out, and veiled-over forms, with equally extraordinary composite creatures, and with a strange collection of buildings and constructions stretching to all sides, all of which we have seen in embryo in previous works. Earth, water, fire, and phantasm-infected air become an all-permeating, pulsing, interpenetrating unity as in no picture before this. The terrain, at the same time close and distant, is

so intricate, so vast, so veiled and hazy, that when curious, strangely seductive, and willfully enigmatic creatures pop up in it, they seem to be perfectly understandable denizens of such a setting. The fact that everything here is interrelated, that anything can suddenly transform itself into everything, is so immediately self-evident that behind it all must lie the speculations and experiments of the alchemist. Thus, the world of the Late Antique Egyptian secret and coded folklore of alchemistic changes becomes, in this work, the fountainhead of the temptations that will endlessly plague the saintly Anthony and which he will resist. We wonder, for example, if the vessel and husk forms that are so frequent here as "containment" forms may have been the basic forms as conceived by earlier practitioners of alchemy.

On the left wing of the triptych, we enter Saint Anthony's nightmare with Bosch, who might be the man in red helping the saint across a bridge. Beneath the bridge, a troll reads and a bird ice skates; trolls are familiar folklore, and the bird might be part of a lost local proverb. The earth itself is a "vessel." Just above the midpoint line of this panel, a giant burrows through the earth, but the vessel shatters and there he is, back in the world where he must do penance. A giant fish, partially contained within a scorpion shell on wheels, carries a tower and devours a smaller fish; the tower resembles a medieval war wagon, and a well-known proverb of the time notes, "Big fish eat smaller fish." Near the feet of the giant, one sees a bishop interacting with a stag-headed creature. During Lent, carnival dancers wore leather animal-headed

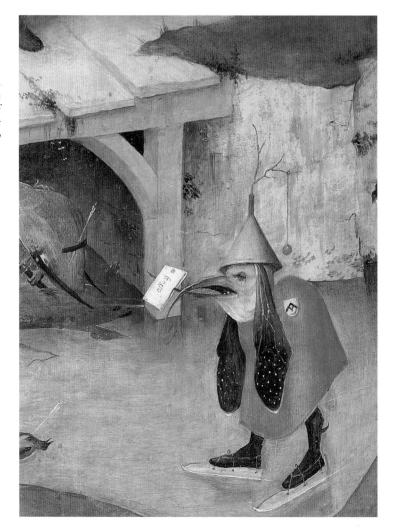

Detail from the
left wing of
*The Temptations
of Saint Anthony*

masks of boars, cranes, and stags. The horns are a symbol of the cuckolded man and represent the sin of lechery.

The sky is filled with hybrid aircraft made from rodents and reptiles, men and fish, plants and boats. These airborne grotesques could be drawn from contemporary apparitions of flying monsters illustrated in contemporary woodcut newsletters or broadsides.

Sound Byte:
"These are panels of various scenes, simulating seas, skies, woods, and many other things that are so pleasing and fantastic that it would probably be impossible to describe them properly to those who have no knowledge of them."

—ANTONIO DE BEATIS, critic, 1517

A Quiet Place

The entire triptych from the wings inward focuses on the calm figure of Saint Anthony kneeling before an altar in a collapsed tower. (Saint Athanasius described Saint Anthony's retreat as an abandoned fort in the desert.) He looks out at us, but his gesture of benediction indicates the presence of Christ and an altar in a chapel in the shadows. Between them is an empty, silent space, a visual metaphor for the peace offered

by Anthony's faith. Around this spot, all hell has broken out—Saint Athanasius describes it as a witches sabbath and eruption of bestial visions. Smoke from a burning town smudges out the sky. Airships bred of birds and boats sail overhead while, paradoxically, fish as boats sail below.

Demonic throngs edge in from the sides, each with a humanoid inhabiting a dead tree. On the left, one is armed and militant; on the right, one rides a rat while clutching a baby in a satanic parody of the Flight into Egypt.

A musician, ever a favorite in Bosch's Hell, joins a table monitored by a gaudy bishop; he indulges in the excesses of wine, women, and song. This might be a local reference, since the musician:

- wears a stag head as seen in carnival masks

- has an owl perched on his head as a symbol of foolishness (owls grow wise only in Victorian fairy tales)

- is identified by the insignia on a badge pinned to his coat. Whose house or guild does he represent?

Once again, Bosch shows his faith in Christ but is dubious of the clergy.

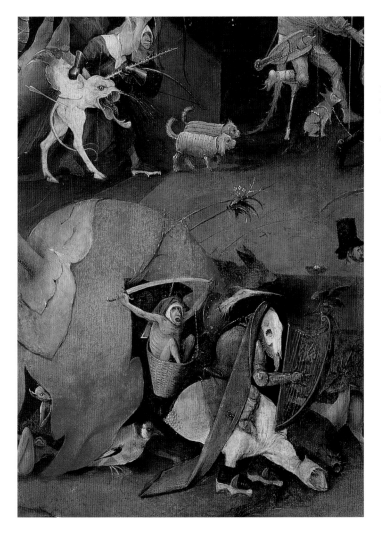

Detail from the
central panel of
*The Temptations
of Saint Anthony*

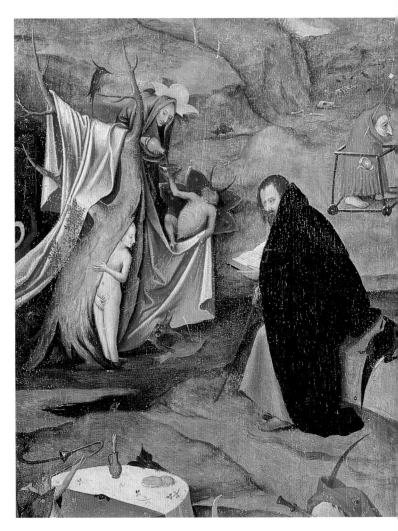

Detail from the right wing of *The Temptations of Saint Anthony*

The Call of the Girl

Unlike the abstract theme of salvation through prayer in the middle panel, the right wing—like the left—is a narrative, the temptation of the saint by a beautiful girl. This misogynist episode—a nasty medieval expression of fearful contempt of women—pits the saint and his Bible against the allure of a slender nude in the hollow of a dead tree.

The dead tree is a favored motif in Bosch's work, probably as a reference to the dry tree that awaits Christ for regeneration or to the *arbor mala* (i.e., the Tree of Evil). Nakedness, a sufficient indication by itself of shame or sin in medieval morality, might also identify this girl as Eve, again offering temptation. The red cloth draped over the tree is a possible allusion to prostitution—there are demons partying here.

Anger (*Ira*) is also here as the outcome of **Excess** (*Luxuria*): Wounded nudes lie beneath a table. And there is the cruel humor of paradox: An adult gnome inches along in a toddler's walker, carrying a child's whirligig toy. Here is the old proverb of a "world upside down."

Moses is seen delivering the tablets of the Ten Commandments on a column to the right of Saint Anthony's retreat. Normally this would indicate the passing of the Old Law but, in matters of temptation, what is normal?

As to flying machines, Bosch's contemporary, Leonardo da Vinci, similarly invented and drew methods of air flight, although his were mechanically, not demonically propelled.

There is more of misery in this painting than of wicked sorcery, as shown by the frightening apparitions, victims of misery and yet entirely self-possessed, who surround the hermit, harass him, and even tempt him. As for their prey, does he really hold his own? He may stand steady and resist their coils, but he cannot be said to be master of the situation.

The world he finds himself in is under a rule whose laws, and even more whose powers, are not easy to recognize. Whatever it is, that rule is obviously lax, subject to whim and tyranny, and is, in part at least, in collapse, its lords divided against each other. At the table, in the central panel, close to the kneeling Saint Anthony, a madly fanatical priest holds out a chalice in a manner commanding and rhetorical, but at the same time questioning.

Everywhere, wanton mischief is intermingled with helplessness. From the far distance, an army seems to invade the picture. The pole of attraction for everything is Anthony himself, and he is at the same time perhaps the guarantee that the demonic power will come so far and no farther. But even the sight of temptation saps a person's resolution. Here, one man has stood up against human misery. He has made an end to his own misery. But what about the misery of others? It seems almost as if he has washed his hands of them. The whole panorama of such a temptation is set forth, from impotent surrender to bold resistance, but how it will end and who really rules the world remain a mystery. As for the world of temptations, seductions, extortions, and violent attacks, even Saint Anthony can exert no influence. Whatever power he possesses is over himself alone.

The Outer Limits

Bosch always envisaged the outcome and its consequences in an obscure and enigmatic way. This was the case already in the four panels known collectively as *Visions of the Hereafter*. Outwardly, they cling to the old themes of Hell and Heaven. But the principal figure in the panel called *Hell* (see page 85) could well be titled *The Forsaken One* as he sits there fruitlessly brooding over the past. The blessed in Paradise in the panel called *The Raising of the Dead* look forward less to the joyful afterlife than to an illumination (or enlightenment) that streams from the cylindrical apparatus that crowns the heights.

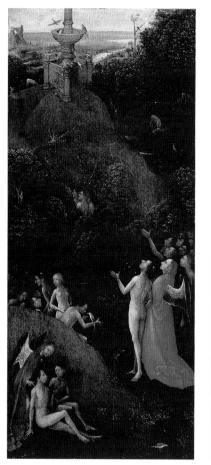
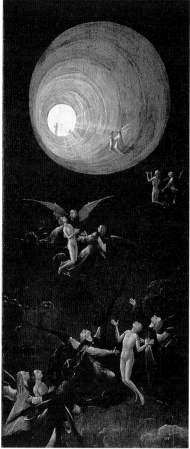

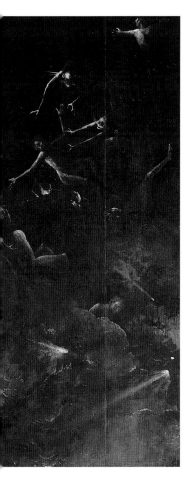
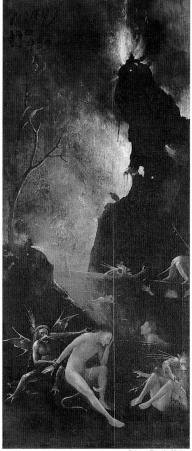

Visions of the Hereafter:
(from left to right)
The Raising of the Dead; Souls of the Blessed Being Flown to Paradise; The Fall of the Damned; and *Hell.* Panels from an altarpiece each 31 ³/₄ x 15 ³/₄" (87.34 x 40.16 cm)

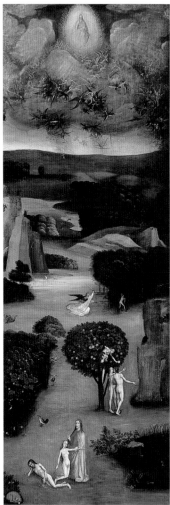

Hell Unfurled

In Saint Anthony's earthly hell, demons perform their torments to distract the saint's attention. In the triptych of *The Last Judgment*, painted at about the same time, torment is physically direct and devastatingly brutal. The theme is derived from the Four Last Things but is focused on a monumental review of Hell. (The Fall in Eden on the left panel is of little importance, save as an introduction to Damnation. It was badly overpainted in early restorations.)

The central panel and right wing are a consistent unit, sharing a common horizon, vantage point, and scale of figures. The color is a major aspect in stylistic unification and an expressive force. Bosch did not experiment here with landscape structure: A simple bird's-eye view was sufficient for this illustrated catalogue of sins and punishments. The result is much like a medieval banner on which small pictures are laid out in rows explaining a religious text or a huckster's wares, as information or an aid to meditation.

Many of the single punishments in *The Last Judgment* are readily discovered in earlier texts that Bosch might have been aware of, as in the documented voyages of the

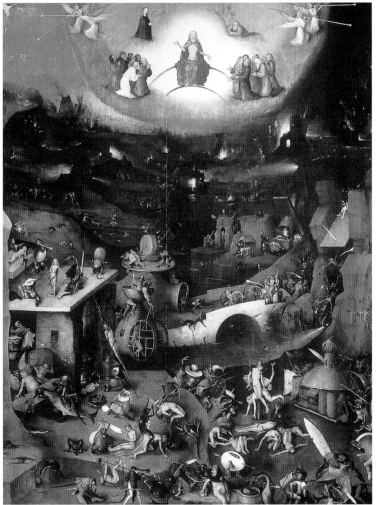

Akademie der Bildenden Künste, Vienna

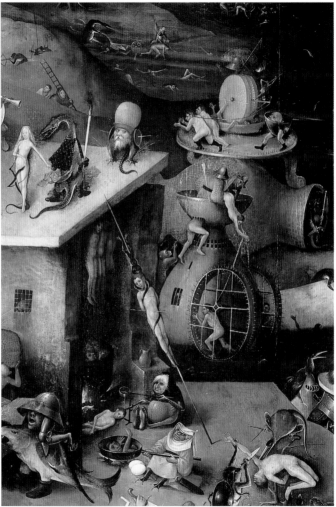

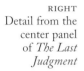

Brandan group, which tell of an island of blacksmiths on their way to Hell. There it is, in the lake in the middle distance, a devil at the forge hammering out a soul. A disproportionately large knife (lower right) bears the mark M, which was probably a guild insignia. Despite a rooftop serenade for a nude at the left (Luxury), two sins dominate these panels: Anger and Gluttony. The results are horrendous: People are stabbed, pierced, and sliced; they are put on spits and are roasted, broiled, and pan-fried. Some people are impaled on dead trees, and a demon cuts away at the limb of one.

The central panel shows the Judge of Judges enthroned in the skies as usual, but the risen dead are still below. As if sentence had been passed some time before, torture apparatuses are already at work everywhere. The entire ordeal takes place on Earth. Only on the right wing does one see the predestined place of final punishment, Hell with its grim gate. That the tormentors are not humans but grotesque monsters is to be understood as Bosch's expression of his shame at being a man among such humans. The violence here is native to the world of humans, effected by machines that humans invent and conceived in what we are forced to call human terms. Nor do the victims cry out, not even at the first pain.

They are apathetic, scarcely aware of suffering. The two varieties of punishment, divine and human, are depicted as interchangeable.

Not to be confused with *The Last Judgment* discussed above is a surviving fragment of another *Last Judgment*, where the devils are less clearly defined creatures than anywhere else in Bosch's work. In the detail shown here from this fragment, we see a woman whose leg is being grasped by a strangely humorous, cartoon-like demon. The devils are more like some by-product of an explosion, though one that has jammed their components firmly together. In no other Bosch painting is there such a gathering of many-limbed, insectlike creatures, so radiantly evil and where one cannot always tell what is front and what is back, nor if their body parts come from machinery or amputated human limbs.

In the same period when he painted *The Last Judgment*, with its harsh view of earthly traps and troubles, Bosch created other scenes where humans who shun the world are visited with the after-pains of that existence and yet hold fast. On the *Altarpiece of the Hermits*, for example, only the left wing with Saint Anthony still has the usual monsters horribly put together from ill-matched bits and pieces.

Kupferstichkabinett, Berlin

ABOVE
Monsters
Bister-and-pendrawing
6 ½ x 4 ½"
(16.6 x 11.53 cm)

OPPOSITE
"Woman on a Demon,"
detail from a fragment
of *The Last Judgment*
23 ⅝ x 44 ⅞"
(60.3 x 114.4 cm)
Alte Pinakothek, Munich

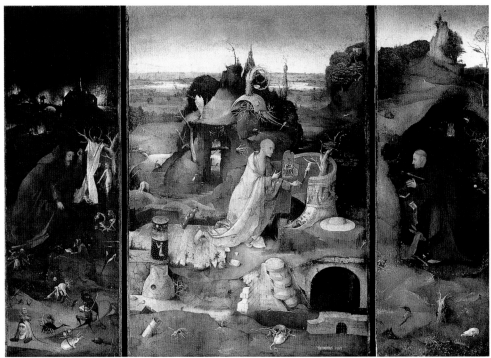

The Altarpiece of the Hermits
Triptych. Wings each
34 x 11 $^3/_8$" (86.7 x 29 cm)
Central panel 34 x 23 5$^3/_8$"
(86.7 x 60 cm)

The Biggie: *The Garden of Earthly Delights*

The triptych now called *The Garden of Earthly Delights* (aka *The Garden of Delights*) is Bosch's defining work, an epic of sustained imagination and interwoven riddles. When the panels of the triptych are closed, the painting on the outer wings shows the Earth as a disk floating obliquely within a larger circle. The greenish-gray disk represents the dry land of the planet Earth on the third day of creation, as yet without creatures but with strange rock outcroppings and mineral formations that might possibly be prickly, bulbous plants, which will appear again inside as the terrain of Eden and the great garden in the central panel.

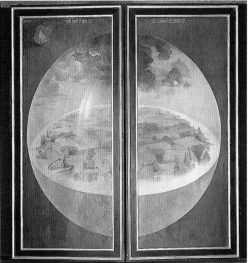

The Prado, Madrid

ABOVE
Exterior of *The Garden of Earthly Delights* with the shutters closed
86 ⅝ x 76 ¾"
(221 x 196 cm)

LEFT
A computer reconstruction of *The Garden of Earthly Delights* triptych

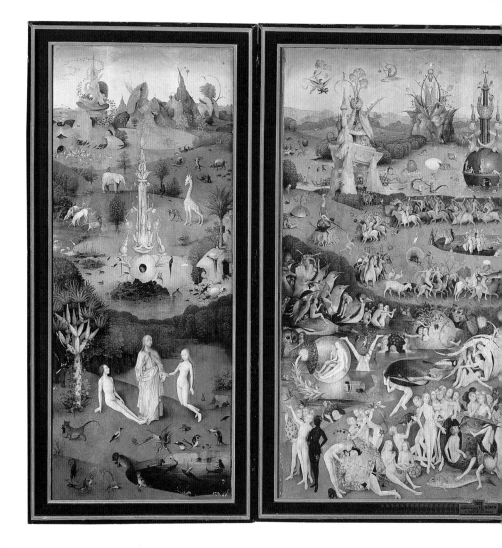

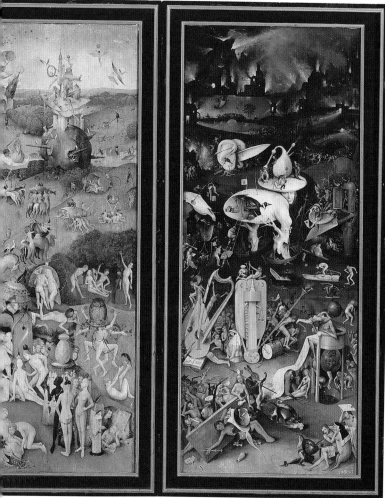

The Garden of Earthly Delights Triptych. Wings each 86 ⅜ x 38 ⅛" (220.32 x 97.3 cm) Central panel 86 ⅝ x 76 ¾" (221 x 196 cm)

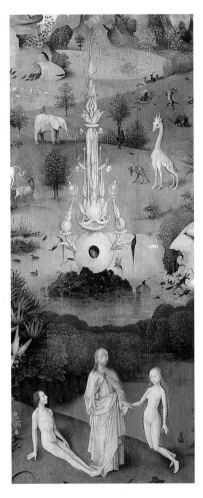

The Left Panel: Paradise?

When the triptych is open, the beginning and end of Bosch's narrative are evident on the lateral wings that show a form of Eden and Hell. The central panel, from which the triptych has always taken its name, must, in fact, be at best an intermediary step, an unsure and unstable interlude between these two extremes that we see on the two wings. The ever-changing ways of the world are present everywhere in the triptych, if only by implication.

Even the Garden of Eden, on the left wing, is far from usual: It is not God the Father, the Creator, who is in charge here, but Christ who brings Eve to Adam. Unlike the way he is usually depicted, Adam is already awake and beholds his predestined mate. From the start, **sight is a major motif**, and throughout the triptych it will be the most important of the senses, more than any other. Everywhere in the work, the mutual gaze will be the clearest form of contact between individuals. Whatever happens, each "act"—whether joyous and sensual or terrified—proceeds from sight. Thus, to paint in

this manner the first pair of humans is to make seeing and desiring one and the same act.

There is a bizarre, swollen, exotic tree close to Adam, but it is more likely to represent a composite of all the trees of whose fruit the pair may eat without being punished. On the other hand, the forbidden tree is a palm at some distance from them, halfway up the picture on the far right side (see page 94), encircled by a serpent and located in that part of the garden which, unlike the foreground, is touched with weirdness.

OPPOSITE
Detail from the left wing of
The Garden of Earthly Delights

The entire background of this left wing is a landscape that contains ominous signs of the exile to come, most notably the presence in the midst of peaceful animals of others that are hostile, or are out for prey, or whose deformed appearance bodes no good. Look, for example, at the long-eared, two-legged creature prancing around upright as a human. Notice, too, the flesh-colored gleaming tabernacle poised on a hollowed-out mill-wheel and rising from the pond. It is so ingeniously artificial that one cannot help but think of the landscape around it as gripped in some unparadisiacal spell, an impression that becomes stronger as one's eye travels into the distant background. There, the mountains strike one as artificial accumulations, if not outright constructions—not dwellings, but already hollowed out as if to serve as refuges in case of need brought on by some future catastrophe. In the blue distance rise prickly mountain peaks, the forms of which are storm-tossed: Peaks shoot high like explosions that have ripped open

97

the boilerlike casings to leave, still standing, buildings that are products of nature gone mad.

OPPOSITE
Detail from the central panel of *The Garden of Earthly Delights*

Busy, busy, busy

The landscape in the center panel is an expansion of Eden in the left wing. It shares colors, a horizon line, and vantage points with the left wing. Its scale of figures is the same. Even its rock and crystal formations are those of the Creation seen in Eden. The garden of this middle panel represents a world still very far from the Last Judgment, or even from the threat of it. These naked humans seem to bask instead in the utmost joy and are all one in their **nakedness**. No premonition of a less happy fate disturbs them. The composition circles elegantly and with delicate articulation from the remote distances at the top, forward to the lake (or pond) in the middle left and to the meadow overgrown with bushes on the right. For all the many figures, there is no congestion but only the happiness of **togetherness**. Most of them seem to be heading somewhere, perhaps even hurrying, but also seem to prefer merely standing about together, or, less often, snuggling close or dancing. Two of the central themes are *the quest of others* and *blissful caprice* (i.e., "do what you want"). Actual physical union—except for what's going on in the clamshell being carried across the scene—is most often implied by the spherical blossoms, pavilions of coral, and glass turrets where they gather. The **facial expressions**, often lost in delight, reveal more than the actions, because for the many figures in this picture,

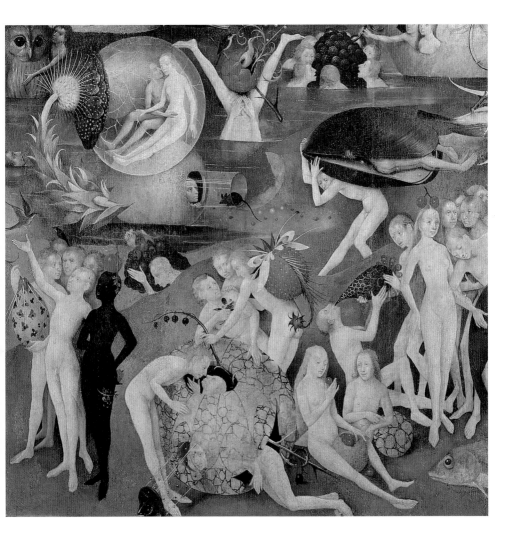

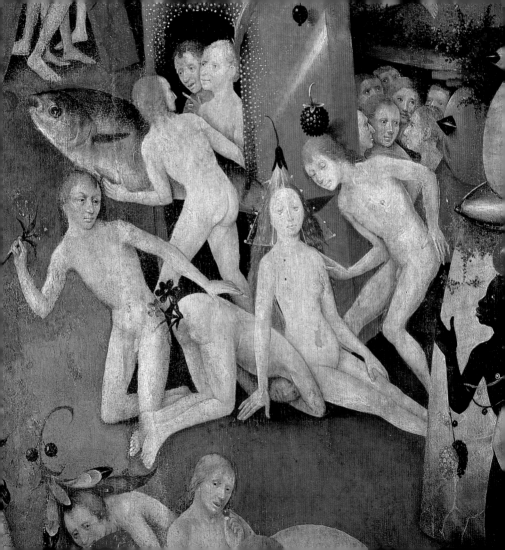

sight itself still signifies only expectation and longing. Nothing binds them except the present moment.

In this central panel are constructions that confine the action to the area running forward right down to the lower margin of the panel. They are more like real buildings than natural outgrowths, though they are fantasy creations. Of those farthest to the rear, the blue-and-pink one left of center looks like clouds frozen into rock; the entirely pink one right of center seems as if formed in some sort of pink clay and then blasted through by sharply pointed bluish-green shapes resembling bombs. The one to the fore on the right resembles a spherical fort bristling with gray, screwlike alabaster tubes and covered over with pink barklike roofs. The entirely pink one on the left looks like a funeral monument erected out of odds and ends found in nature.

OPPOSITE
Detail from the central panel of *The Garden of Earthly Delights*

The purpose of these fantastic buildings is to **define the body of water** with its four rivers flowing in or out, and to offer their hollow interiors as shelter to the bewitched human beings. The naked figures also seek shelter on the banks and in the sea, gathering in throngs in or around fruits, shells, and a giant egg, or floating about in boats that sometimes are alive with mythical creatures. The distant zone with these edifices is the fountainhead of the entire painting. It is there that one must begin to read this picture whose action flows easily forward and to all sides.

Here, the terrain is new and without precedent in any of Bosch's previous

works. One symbolic sign follows fast on another. Viewed as a whole, this is not a labyrinth but a topography of zones carefully set off against each other. Like the tower area, the zone in front of it is still firmly defined by close concentration about the round pool where the women bathe. This is the first point in the picture where a dynamic movement appears to be unleashed: Bosch shows the savage but uncontrolled circling chase of the troops who, mounted on wild, domesticated, or fabulous beasts, reveal their separate naked ecstasies while at the same time submitting to the disciplined frenzy of the mass.

Only in the third and foremost zone are the nude couples and groups free to interact at will, alone and often transported out of themselves and already giving in to a kind of **worried dissipation**. This is also characterized visually by the large, round fruits that recur throughout the zone, often glassily transparent or afloat like boats, or rolling across the meadow. Shells and shelters for lovers, they not only envelop the amorous couples but are at the same time the secret signs of the desires to which they surrender themselves.

The three zones remain distinct, and only the last of them—the foremost plane—shows everything as if suspended and intermingled, cropping up or dying away, and often both at once. An **enchantment comes over everyone** and holds each individual so intensely that he (or she) can scarcely be aware of anything except himself and his deepest desires. This, in fact, is the primary meaning of the composition: Bosch

portrays less a tangled crowd of human bodies than a vast terrain of their wide-soaring hopes. This is why so much is hidden, telescoped, disguised, and covered over. The chief theme of the picture is the hushed expectancy and a quest after the unexpected. The enormously oversized birds at first seem a menace, but they do no more than toy with the fruits they have sought out, or else give them to naked humans. There is **a joyfulness in all these nudes,** however much they may strike us as frail, unhinged, and forever insecure and almost haunted. Yet there is more: In the midst of this celebration of joy, there is **death and extinction**. Certain figures turn away, their hope abandoned, from the very pleasure to which they had been clinging with such passion a moment earlier. This is because the evil inherent in death is a principle present from the outset in sin.

Some critics see in this panel the state of **humankind on the eve of the Flood,** when people still pursued pleasure with no thought of the future, their only sin being the unawareness of sin. This overcomes the puzzling problem arising from the fact that, in this triptych, the left wing quite definitely depicts Paradise, though already with certain extravagances of nature and many hybrids formed by strange couplings, while the middle panel shows another paradise, this one morally more free, virtually libertine, and concerned only with humans. Many critics believe that, in no way whatsoever do the three panels present a continuous tale of decline and fall. Look at the figures' faces, behavior, and gestures and you will see that although most of these unclothed people

share a common interest, each denies his neighbors, pushes them away impetuously, and is no more than passingly aware of their presence.

OPPOSITE
Detail from
the right wing
of *The Garden
of Earthly
Delights*

If one believes that the triptych depicts Paradise, Earth, and Hell, then one might expect to see the Flood in the right panel. But there is no flood. And the Hell we have here does not resemble the old familiar Hell: It is no fiery pit, but is Earth itself in flames. What pushes forward here, little by little, seething and clanking, seems to be nothing other than war and arson. Hordes of armed men race into the scene, their naked victims rushing on helplessly before them, many only to be crushed beneath a monstrous juggernaut made up of two giant ears flanking a huge knife.

But then the terrain changes to ice and not many can escape across it. A few slip and slide about while others crash through. Those who do succeed are not much better off. They reach dry land, but only to become imprisoned between huge instruments that once meant no more than delight and music, or they end up tortured, crushed, impaled on an overturned table or devoured by the bird-headed specimen enthroned on his royal toilet. The tormentors are not traditional devils, but are those conglomerates invented by Bosch out of parts of wild beasts, reptiles, and armor-plated instruments. The most impenetrable riddle of all is the **mysterious creature** who bestraddles the center of the picture with, for legs, two dead tree trunks planted in two light boats, for his body an egg burst open to reveal a dusky cave where people

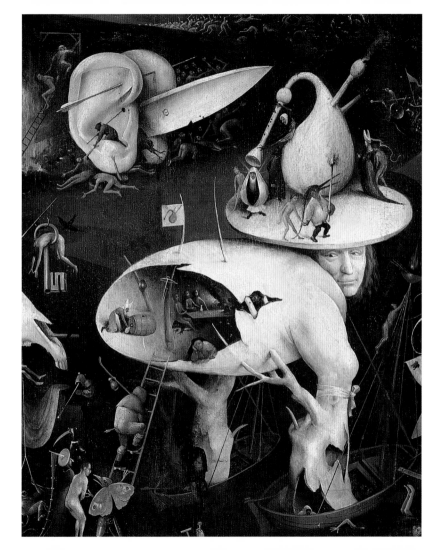

sit at a table. His head is a melancholy human face (is it Bosch himself, surveying this crazed world?) looking out at us from beneath a mill-wheel hat. Not particularly molested by the animal specters, a pair of humans clamber up a ladder to the cave inside him, one of them stocky and, despite the arrow in his rump, apparently quite undisturbed. But all around are figures undergoing some sort of suffering. What is he meant to be, this innkeeper whose inn is his own body? The void of existence? Bosch himself seems to have created this conceit as a riddle not to be unraveled.

The Prodigal Son
Diameter 27 $^3/_4$"
(70.76 cm)
Museum
Boymans Von
Beuningen,
Rotterdam

Coming to Rest

Bosch painted at least two masterpieces after the summit of the great triptychs: *The Adoration of the Magi* (the version that hangs in The Prado) and *The Prodigal Son* (aka *The Wayfarer*). These works, evolved from his earlier interests in genre realism and naturalistic landscape, are spiritually quite unlike his earlier work. They manifest themes of hope and redemption, which in turn inspired the most compassionate and peaceful art in Bosch's career.

The parable of the prodigal son (Luke XV: 11–32) offers an old but unexhausted warning: Boy squanders family savings on gambling, booze, and whores; wakes up with pigs and wanders home broke; repents sincerely and is forgiven by his father. It is an optimistic promise that love and atonement can achieve reconciliation and forgiveness.

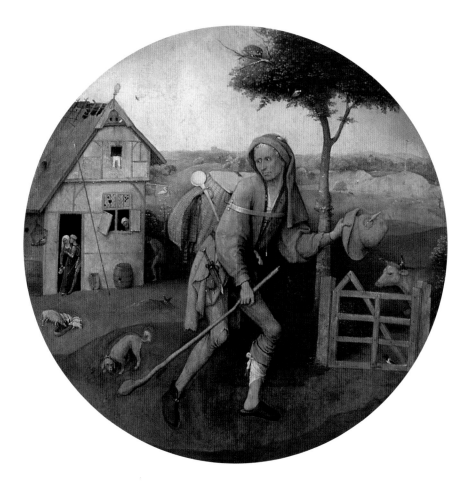

The basic composition of *The Prodigal Son* reminds us of the one found in Bosch's earlier painting of *The Vagabond* on the outside shutters of *The Hay Wain*. It shows great growth toward simplicity in organization. Here, Bosch the realist shows himself once again to be a master of telling detail. The dilapidated bordello, from its failed thatched roof to broken windows and unhinged shutters, is an architectural metaphor for a life in ruins.

The four inhabitants seen in the window, doorway, and at the side of the building aren't even metaphors. Like the pigs at the trough, they are what they are.

On our right, opposite the tavern, a gate leads past a resting cow into a simple, low-rolling farmland. The bordello is one world, but beyond the gate is another. Each has a moral value, but both are understood as part of the real world. The *tondo* (i.e., circular) format of *The Prodigal Son* lends an optimism and natural realism to the piece.

This kind of "natural" (i.e., "disguised as reality") symbolism in Bosch's late work is readily seen in the many purposes served by the gate: It creates a visual balance for Bosch the adroit designer, but it also provides a challenge to a returning wastrel, a barrier between the morally distinct worlds of waste and work. It is now up to the Prodigal to decide which side of the gate he will remain on.

The Artist complete

In his last, mature triptych, *The Adoration of the Magi*, Bosch discovers a new unity of spirit, nature, and realism. The altarpiece was commissioned by a couple who wished to appear as witnesses to this Epiphany—the moment of divine revelation recognized by the Three Magi (Wise Kings from the East). The distance of time and space between the world of Mary, Joseph, and Christ—and that of the three Magis—is demonstrated by the latter characters' isolation with their patron saints on the lateral wings. Their spiritual communion with the Adoration is explained by the landscape backgrounds.

These landscapes are of a single terrain: a late medieval urban countryside of pastoral labor and feudal play. A great city rises on the horizon, complete with round temples and a windmill. The temples were a standard medieval identification of Jerusalem, although the landscape and windmill suggest that this Jerusalem is in Brabant.

The Wings

The wings show vignettes relative to the Epiphany. On the left, a ruined wall gives barest shelter to a woman huddled by a fire. Presumed to be a Synagogue, a symbol of the old law of Judaism that gave way to the new order of the Church, her nun's habit of Franciscan gray might refer to local issues or quarrels. On the right, a small lamb lies

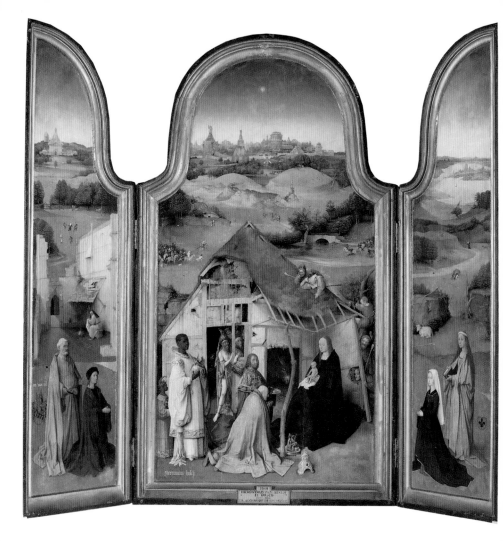

by a shepherd's staff. It is the Lamb of God. The staff is the symbol of Saint Peter, the first pope.

Outside and In

The integral focus of this triptych comes together in the rambling hovel that dominates the entire work. In the barest range of light tans, Bosch makes palpable the loose straw of a thatched roof, the fragility of the branches supporting the outer shed, and the gaping, crumbling plaster fallen from its wattle lath of woven reeds. With sustained realism, Bosch convinces us of the reality of the miraculous revelation at the shed alongside a miserable hovel.

A moment of profoundly gentle humor graces the shed on the right as shepherds, poor and illiterate, struggle for a view of this event. Climbing a tree, peering through a gap in the wall, they represent an essential point of humane Christianity's mission to the poor and humble. From inside the hovel, a crowd presses forward, its discolored and distorted faces from Bosch's past world of angry caricatures.

They group behind a mysterious mockery: a half-naked king crowned with a turban of thorns and an hourglass, his arm fastened in a bracelet tethered to a chain that vanishes behind the doorway. He is the resident of the hovel, chained but seemingly benign; his costume is meaningless, as his naked state belies any real status. Answering an old medieval debate about the role of reason in the perception of miracles, the madman

OPPOSITE
The Adoration of the Magi Triptych. Wings each 54 ³/₈ x 13" (139 x 33.15 cm) Central panel 54 ³/₈ x 28 ³/₈" (139 x 72.42 cm) The Prado Madrid

shows a recognition of the divine child directly from the senses to the soul without the use his damaged mind.

All good things

Bosch's death in 1516 hardly stopped demand for his art. He had employed studio assistants for copying some of his paintings, but now reproductions were joined by imitations and outright fakes. In the middle of the 16th century, the Spanish King Philip II collected every important Bosch he could find. By then, imitating Bosch had become a cottage industry in the Netherlands. The artist **Pieter Brueghel** (c. 1525–1569), for instance, began his career in the mid-century as an outright but brilliant imitator of Bosch.

We could spend pages summarizing all that we've discussed in this book, but why bother? You already know the key points of Bosch's life and work. Instead, here's something fun to remember about him: In 1933, Hollywood film choreographer Busby Berkeley needed a production number for a comedy called *Roman Scandals*, starring Eddie Cantor. He loved Bosch's *Garden of Earthly Delights*, so he set his own "Garden of Earthly Delights" in a Roman bath, complete with Goldwyn Girls and surprise guests from Central Casting. *Entre nous*, how could Brueghel top this?

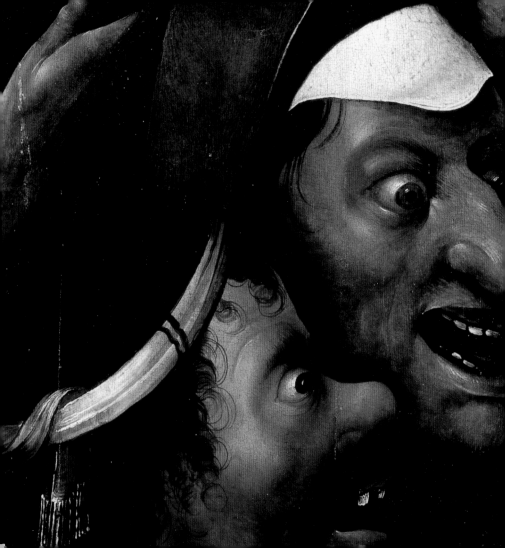